DANTE GABRIEL ROSSETTI

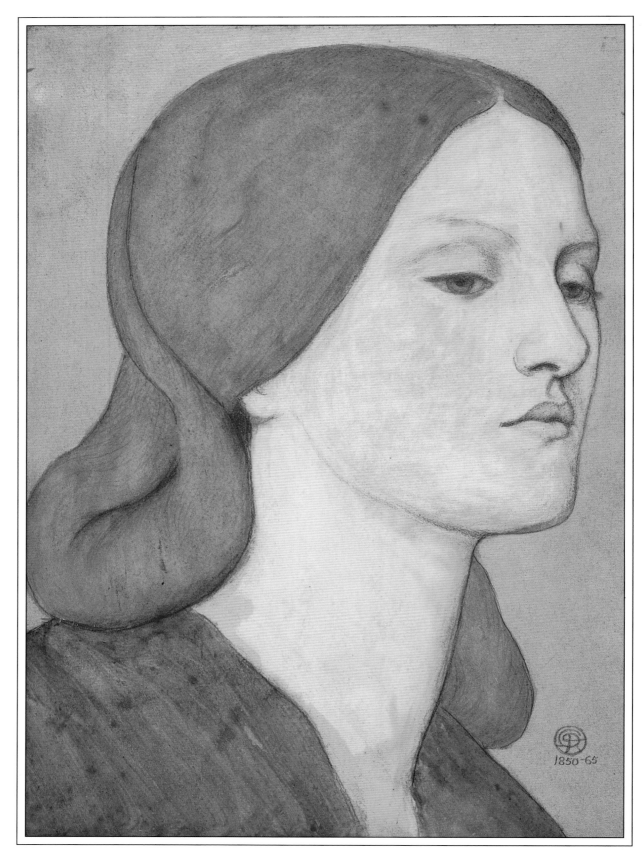

Portrait of Elizabeth Siddall, 1850–65

DANTE GABRIEL
ROSSETTI

Russell Ash

BCA

LONDON NEW YORK SYDNEY TORONTO

DANTE GABRIEL ROSSETTI
1828–82

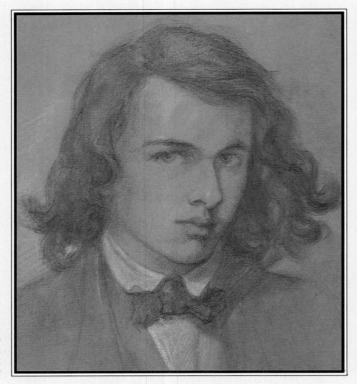

Dante Gabriel Rossetti's romantic self-portrait, drawn at the age of 18, in March 1847

Gabriel Charles Dante Rossetti was born in London on 12 May 1828 in the family house at 38 Charlotte Street, a run-down area to the north-west of the British Museum. His mother was Frances Polidori, the sister of Byron's physician John William Polidori, who came from an Anglo-Italian literary family. His father was Gabriele Rossetti, from Neapolitan peasant stock but with strong poetic leanings and a lifelong obsession with the poet Dante – hence the exotic name conferred on his first-born son.

Gabriele had attended the University of Naples and had subsequently held various positions – including that of a librettist to Rossini at the Naples Opera House and a museum curator – but after becoming a political exile he had travelled to Malta and then on to London, where he settled in 1824. There he worked as a teacher, and in 1831 he was appointed Professor of Italian at King's College. By then all four of his children had been born: Gabriel (or Dante Gabriel, as he reversed his name to give precedence to his poetic namesake); his elder sister Maria, who became an Anglican nun (the religion followed by the women of the household); his younger brother William Michael, who worked in a government department but developed a second career as a critic and historian of the Pre-Raphaelite movement; and their younger sister Christina, a poet celebrated for her authorship of religious and other poems, including *Goblin Market* and the Christmas carol *In the Bleak Mid-winter*.

After home tuition and attendance at a local school, with his brother William, Dante Gabriel Rossetti went to King's College School in 1837. The rigorous education provided there taught him Latin and Greek but he was a restless and academically unsuccessful pupil, and left at the age of 13. What he lacked in formal learning, however, he more than made up for through his reading and the cultural stimulation he received in the bilingual and intellectual Rossetti household. His parents were also unusually liberal for the time, so that when he announced that he intended to become a painter he was positively encouraged: in fact, torn between his twin passions for poetry and painting, he decided to pursue both. He was ultimately to combine his two aspirations by appending self-penned sonnets to the frames of his paintings.

Rossetti began his study of art at a private school known as 'Sass's', a sort of preparatory school for those intending to enter the Royal Academy. His four years there were no more successful than his schooldays, however, as he found the school's emphasis on formal technique incompatible with his temperament. His next move, to the Antique School of the Royal Academy, was similarly unsuccessful, although Rossetti's charismatic personality began to be revealed to the circle of admirers that gathered round him. His sense of humour was a notable feature, coupled with his skill in caricature and writing impromptu and witty limericks about his friends and enemies. His dashing Italianate looks are presented without exaggeration in a self-portrait drawing dating from 1847, while a contemporary's recollection quoted by his biographer Henry C. Marillier could have described many an art student of today:

'Thick, beautiful, and closely-curled masses of rich, brown and neglected hair fell about an ample brow, and almost to the wearer's shoulders; strong eyebrows marked with their dark shadows a pair of rather sunken eyes, in which a sort of fire, instinct with what may be called proud cynicism, burned with a furtive sort of energy. His rather high cheekbones were the more observable because his cheeks were roseless and hollow enough to indicate the waste of life and midnight oil to which the youth was addicted. Close shaving left bare his very full, not to say sensuous lips and square-cut masculine chin. Rather below the middle height [he was 5' 7" tall] and with a slightly rolling

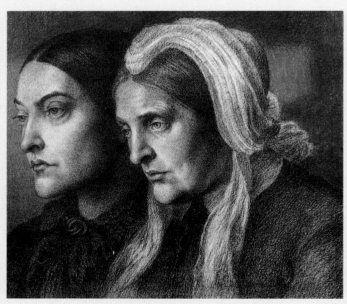

Rossetti's sister Christina and their mother Frances, 1877

gait, Rossetti came forward among his fellows with a jerking step, tossed the falling hair back from his face, and, having both hands in his pockets, faced the student world with an insouciant air which savoured of thorough self-reliance. A bare throat, a falling ill-kept collar, boots not

over familiar with brushes, black and well-worn habiliments including not the ordinary jacket of the period but a loose dress-coat which had once been new – these were the outward and visible signs of a mood which cared even less for appearances than the art student of those days was accustomed to care, which undoubtedly was little enough!'

Rossetti's appearance was in keeping with the prevalent mood of the age, with its romantic revival, but he was ahead of the public at large in his appreciation of, for example, the poems of John Keats, who was then unfashionable, and William Blake. In 1847, while still a student, he acquired one of Blake's notebooks from George Palmer, a British Museum attendant, for 10 shillings, and contributed an essay on Blake's art to a biography.

He left the Royal Academy before his twentieth birthday and before moving on, as was customary, to the Academy's Life School. This abandonment of his training has been seen by some, unfairly, as explanation for his supposed inability to paint nude figures that are anatomically correct: in fact he did continue his studies, attending classes at which he painted from life models, elsewhere.

At this stage he had a vague idea of relinquishing painting in favour of poetry (the métier that his sister Christina was now pursuing), writing his poem *The Blessed Damozel* and translating the works of Italian poets. At this crossroads in his professional life he sought the advice of several eminent men: the poet and painter William Bell Scott; Leigh Hunt (who dissuaded him from attempting to earn a living as a poet); and the then little-known painter Ford Madox Brown.

Brown was one of a number of hopeful young artists who four years earlier had entered a competition to paint the murals in the new Houses of Parliament. Rossetti had seen his entries and other works by him, and he wrote such an effusive letter to him that Brown assumed he was the victim of a hoax, and allegedly visited his unknown admirer armed with a stick. Such was Rossetti's charm, however, that the two men became immediate friends, Brown accepting Rossetti as his pupil without charge.

Rossetti began working in Brown's studio, but quickly tired of painting the still lifes that Brown set him as lessons, so that although Brown remained an ally and mentor, he very soon changed teachers. He had seen his fellow Academy pupil Holman Hunt's *The Eve of Saint Agnes* (Guildhall Art Gallery, London), based on the poem by his beloved Keats, when it was exhibited at the Royal Academy in 1848. Rossetti warmly praised it, ingratiated himself with Hunt and moved to his studio, where he started his first major oil painting, *The Girlhood of Mary Virgin*.

Brown had been influenced by the Nazarenes,

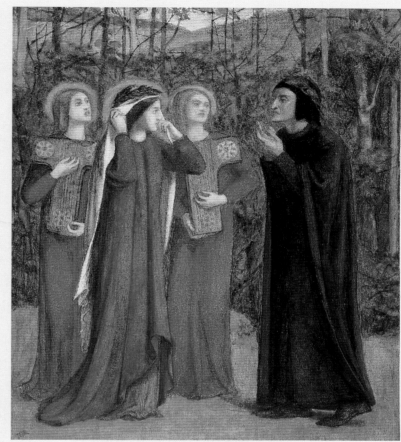

The Meeting of Dante and Beatrice in Paradise, c.1852, a watercolour from Rossetti's medieval period.

Study for a portrait of Rossetti by his friend Holman Hunt, 1853

a group of contemporary German painters who followed a style that emulated early Italian masters. Their artistic intentions became a component of discussions between Brown, Hunt, Rossetti and other like-minded men, as a result of which the Pre-Raphaelite Brotherhood was founded in September 1848, holding its inaugural meeting at the home of the parents of John Everett Millais, in his studio (a converted greenhouse at the back of the house). 'Pre-Raphaelite' described their aspiration to return to the style before Raphael, while the notion of its being a 'Brotherhood' was probably suggested by Rossetti. More than 25 years before the Impressionists did so by exhibiting in public, the Pre-Raphaelite Brotherhood was the first group avowedly to set itself up against the artistic establishment. Rossetti's father had inculcated in him a belief in Freemasonic conspiracies and told him tales of secret societies, such as the Italian Carbonari; and he was probably the one who urged on the group the need to keep their innocuous revolution to themselves. Thus it was decided that the only outward sign of their membership of the Brotherhood would be the three initials, P.R.B., added to their paintings. Their ideals were simply set out in a short manifesto:

1. To have genuine ideas to express;
2. To study Nature attentively, so as to know how to express them;
3. To sympathize with what is direct and serious and heartfelt in previous art, to the exclusion of what is conventional and self-parading and learned by rote;
4. And most indispensable of all, to produce thoroughly good pictures and statues.

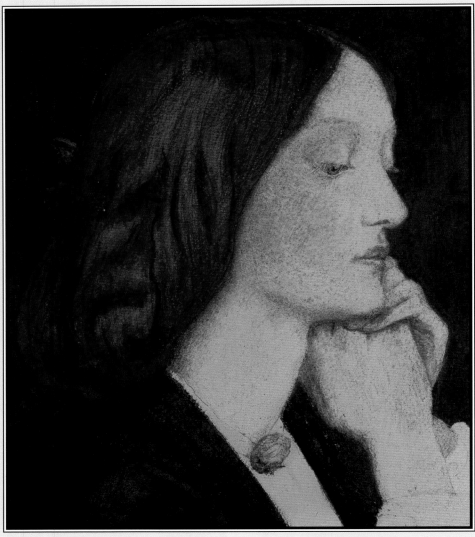

One of Rossetti's numerous haunting portraits of Elizabeth Siddal, 1854.

Its founder membership consisted of seven men, not all of them painters: Dante Gabriel Rossetti and his brother William Michael, James Collinson (for a while Christina Rossetti's fiancé), William Holman Hunt, John Everett Millais, Thomas Woolner, a sculptor, and Frederic George Stephens. Ford Madox Brown excluded himself.

The P.R.B. members' choice of subjects was broad, encompassing religious, medieval, literary and contemporary themes, with an underlying ideal rooted in moral values or commentary on current social problems such as emigration, drunkenness, gambling and sexual vice. Paradoxically, however, in many of their works – especially Rossetti's – they adopted an idealized and escapist view of an imaginary 'golden age' rooted in the medieval world, with its traditions of courtly love and chivalric duty. While this reflected one of the passions of the Victorian age – an omnivorous hunger for the past that manifested itself in literature, with the popularity of Walter Scott and other romantic authors, and in the Gothic revival in architecture and decoration – it was essentially detached and morally neutral, as its critics noted.

As a focus for the artistic aspirations of a number of individuals, the Pre-Raphaelites and their influence lasted far longer than the Brotherhood itself, which had all but ceased to exist within five years, as each member pursued his own interests. Millais, for example, became immensely successful, exhibiting at the Royal Academy and achieving great wealth and fame; Collinson resigned when he decided to become a Roman Catholic priest; F. G. Stephens turned his attention to writing and art criticism; while Woolner emigrated to Australia to seek his fortune as a gold prospector (he failed to do so and soon returned to England, where he became a moderately successful establishment sculptor, and ultimately a Royal Academician).

Rossetti's *The Girlhood of Mary Virgin* was the first painting ever exhibited with the mysterious P.R.B. initials. It was shown at the Free Exhibition that opened in London on 24 March 1849, pre-empting the opening of the annual Royal Academy exhibition, which opened the following month. It was generally well received and was acquired by the Marchioness of Bath (a friend of his mother's family) for £80. With the proceeds from this, his first sale, Rossetti travelled to France and Belgium with Hunt, and was profoundly affected by the medieval religious paintings he saw.

Back in London, with several new recruits to his group, in January 1850 Rossetti founded *The Germ*, a journal devoted to the Pre-Raphaelites' interests in art, literature and poetry. It contained poems by Christina Rossetti (writing under the pseudonym Ellen Alleyne) and Rossetti's

poem *The Blessed Damozel*, but it was a financial failure and only four issues were published. In the same year several artists exhibited works with the P.R.B. acronym at the Royal Academy. Rossetti rashly explained its meaning to an outsider, the secret came out, and they were criticized for their audacity in a number of publications. The next year, however, the art critic John Ruskin leapt to the group's defence both in letters to *The Times* and in subsequent lectures, so that just as the Pre-Raphaelite Brotherhood began to break apart its component artists started to achieve public recognition.

To Rossetti and his friends, any strikingly attractive woman was a 'stunner' (an expression that first appeared in print in 1848, the year the Pre-Raphaelite Brotherhood was formed). Elizabeth Siddal was the first of the stunners who were to dominate his paintings. Rossetti had met Elizabeth, or Lizzie, Siddal (or Siddall, as her father spelled his name) late in 1849. She was born in London on 25 July 1829, the daughter of a Sheffield cutler whose family claimed noble ancestry but lived in a modest home in London. Lizzie worked as an assistant in a milliner's shop. It is hard to comprehend today, but in the nineteenth century women working in this trade – partly because they were poorly paid – had a reputation for being sexually promiscuous, as is implied in paintings of milliners by artists such as Degas and Tissot. Although Miss Siddal was decidedly not such a woman, she was 'discovered' there by somebody who was probably seeking one who was, the Irish poet William Allingham. He described her to the American-born painter Walter Howell Deverell (an associate of the group, he had just missed being elected to the Brotherhood on the departure of Collinson, and was to die in 1854 at the age of 26). Deverell, who was searching for just such a woman to model for a painting, observed the proprieties of the day by having his mother visit Lizzie's shop, and once Mrs Deverell had established that she was a respectable girl – and she that Walter had no ulterior motives – Lizzie was asked to visit his studio in Kew to pose as Viola for his *Twelfth Night* (Forbes Magazine Collection). She was soon in demand among other members of the group, for her appearance, according to William Michael Rossetti, was that of 'a most beautiful creature with an air between dignity and sweetness with something that exceeded modest self-respect and partook of disdainful reserve; tall, finely formed with a lofty neck and regular yet somewhat uncommon features, greenish-blue unsparkling eyes, large perfect eyelids, brilliant complexion and a lavish heavy wealth of coppery-golden hair.'

Lizzie appeared in Holman Hunt's *A Converted British Family Sheltering a Christian Priest from the Persecution of the Druids* (1850, Ashmolean Museum, Oxford) and as Sylvia in

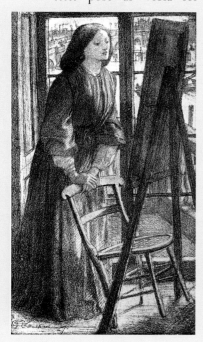

Rossetti's drawing, believed lost, of Elizabeth Siddal in his Blackfriars studio, 1855.

his *Valentine Rescuing Sylvia from Proteus* (1851, Birmingham City Museum and Art Gallery); in paintings by Ford Madox Brown; and most famously as Ophelia in Millais's painting of that title (1852, Tate Gallery). She posed for Millais lying fully clothed in a bath of water kept warm by lamps beneath it (despite which she caught a severe cold – perhaps pneumonia – and her father threatened to sue the artist until he agreed to pay her doctor's bills). Her state of health was always delicate, but never properly diagnosed, and has been much speculated on: consumption (tuberculosis) is the commonest suggestion, but both her exceptionally slender appearance and the clinical progress of her illness, which departed from that experienced with TB, suggest that she was suffering from anorexia.

Nude study for *Ecce Ancilla Domini!*, c.1849.

Rossetti first met Lizzie while Deverell was painting her, and, as he later told Brown: 'when he first saw her he felt his destiny was defined.' He encouraged her to leave her employment and agree to model exclusively for him, and he taught her to draw and paint, which she did with great competence – although his influence is evident. Rossetti produced hundreds of drawings of her (so significant a body of work that they have become the subject of a recent book), and she haunted his canvases for the next decade. Christina Rossetti's sonnet *In An Artist's Studio*, written on Christmas Eve 1856, sums up his obsession:

One face looks out from all his canvases,
One selfsame figure sits or walks or leans;
We found her hidden just behind those screens,
That mirror gave back all her loveliness.
A queen in opal or in ruby dress,
A nameless girl in freshest summer-greens,
A saint, an angel – every canvas means
The same one meaning, neither more nor less.

He feeds upon her face by day and night,
And she with true kind eyes looks back on him,
Fair as the moon and joyful as the light:
Not wan with waiting, not with sorrow dim;
Not as she is, but when hope shone bright;
Not as she is, but as she fills his dream.

Rossetti moved from his parents' house to Chatham Place, near Blackfriars Bridge, with Lizzie in constant attendance. Visitors were discouraged as the two became an increasingly self-absorbed couple. In 1853 Rossetti sold his second painting, *Ecce Ancilla Domini! (The Annunciation)*, to Francis MacCracken, a patron whom – like most of his successors – Rossetti resented and spoke of derogatorily.

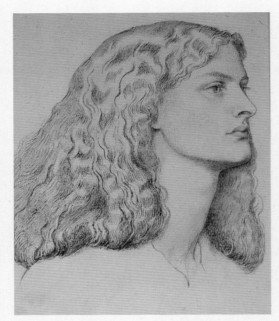

After his first two major religious works Rossetti's art became secular in tone, as did that of the majority of his colleagues, and the early 1850s found him producing, and occasionally selling, watercolours with increasingly rich colouring representing medieval themes, especially those featuring his hero Dante. These included pictures such as *The First Anniversary of the Death of Beatrice*, which Ruskin considered 'a thoroughly glorious work'. Ruskin assisted Rossetti and Lizzie financially, and, perhaps reacting to his benefactor's criticism that his paintings failed to convey any moral 'messages', Rossetti began to paint *Found*. His only truly 'moral' picture, it mirrored his inability to come to terms with his personal life in that it remained unfinished throughout his career.

Meanwhile, Rossetti's relationship with Lizzie was troubling him emotionally. He clearly revered her, but respected her chastity and aloofness – a protective barrier she maintained deliberately to save herself from becoming one of the numberless women whose virtue had been ruined by sinking (the popular, and generally accurate, term) into the morally reprehensible profession of 'artist's model'. It is clear that he thought of their affair – platonic at this stage – as paralleling that of Dante and Beatrice,

with Lizzie as the desirable yet unobtainable woman, her ethereal spirit symbolized by one of his nicknames for her, 'Dove'. (He also called her 'The Sid', while their pet name for each other was 'Guggum'.) But at the same time his desires were undeniable, and he sought release elsewhere. By the curious standards of Victorian morality this was by no means unusual, though his choice of partners was not always well advised. As well as visiting prostitutes (the subject of *Found*), while his friend Holman Hunt travelled to Egypt and Palestine in 1854–55 (where he was to paint his notable work, *The Scapegoat*), Rossetti took the opportunity to conduct a liaison with Hunt's fiancée Annie Miller – as a result of which, his previously warm friendship with Hunt not surprisingly cooled.

This was not the only sexual scandal to affect the Pre-Raphaelite Brotherhood at this time: in 1854 Ruskin's young wife Effie left him, the marriage was later annulled on the ground of non-consummation, and Effie married Millais. It was in 1854 (the year in which Rossetti's father Gabriele died) that Rossetti and Ruskin met and became friends. Ruskin introduced Rossetti to several influential patrons, such as Charles Eliot Norton of Harvard University, and Ellen Heaton, for whom he produced a number of commissioned works. Ruskin also advanced money to Lizzie, but his attempt to control her output of pictures taxed her nervous disposition, and the arrangement soon ended. Ruskin persuaded Rossetti to teach at a Working Men's College, and he continued in this

voluntary labour for at least six years, during which he was to meet Edward Burne-Jones, whom he encouraged to paint, and William Morris, whom he guided into poetry. Though only a few years younger than him, both men revered Rossetti and the two, with others whom Rossetti similarly influenced, were to carry the mantle of Pre-Raphaelitism into the next generation.

In 1855 Rossetti began creating designs for woodcuts, including those for *The Maids of Elfen-Mere* (the work that had led Burne-Jones to visit Rossetti), and in 1856 he started work on illustrations to Tennyson's poems for a book published the following year. Although he was characteristically dissatisfied with both productions, and the so-called 'Moxon Tennyson' (named after the

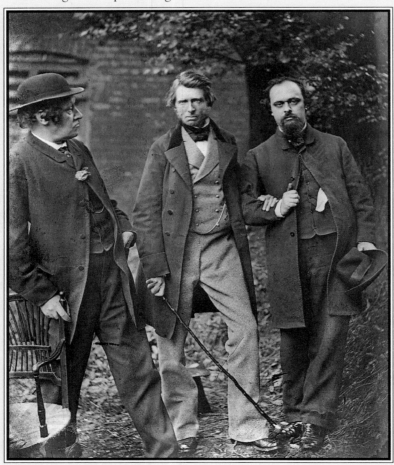

publisher Edward Moxon) was not commercially successful, the latter undoubtedly made him better known to the public. For these subjects he sought inspiration from medieval manuscripts, which in turn led him to produce the watercolours of Arthurian scenes that were to preoccupy him in the next phase of his work: medieval chivalric subjects and doomed romantic themes, with Dante and Beatrice as the dominant characters. His poetry was not neglected though, and examples were published in the Morris-funded *Oxford and Cambridge Magazine*.

In the summer of 1857, during a temporary break in his on-off relationship with Lizzie, Rossetti, along with Burne-Jones, Morris and others, worked on a series of murals in the Oxford Union. Rossetti's favoured Arthurian themes, based on Sir Thomas Malory's *Morte d'Arthur*, were scoured for subjects but it proved an ill-fated project that was never completed, and it suffered from the fact that none of them knew enough about the techniques of fresco painting. It was while work was progressing, though, that two further influential individuals entered Rossetti's life: he met the poet Algernon Swinburne (who modelled for his Sir Galahad, and later lived in Rossetti's house) and Jane Burden, whom the group had spotted at a theatre in Oxford. She entered the circle as a model, appearing in Rossetti's *The Wedding of Saint George and Princess Sabra*, and marrying William Morris two years later.

At about this time Rossetti met Fanny Cornforth. A striking, large woman (Rossetti nicknamed her 'Elephant', and depicted her as one in caricatures) with floor-length blonde hair, her married name was

Money to the House, one of Rossetti's elephant caricatures from his illustrated letters to Fanny Cornforth.

Sarah Cox. She worked on the fringes of prostitution and as an artist's model, and soon numbered Rossetti among her many lovers. His first painting of her, *Bocca Baciata* (1859, Museum of Fine Arts, Boston), which translates as 'lips that have been kissed', marks his return to the oil-painting medium that he had largely neglected since *Ecce Ancilla Domini!* Having mastered the medium of watercolour in these intervening years, however, the transition was easy and the results remarkable. His triptych for Llandaff Cathedral, on which he continued to work in the early 1860s, marks, in Holman Hunt's words, 'the turning point from his first severity of style to a sensuous manner'.

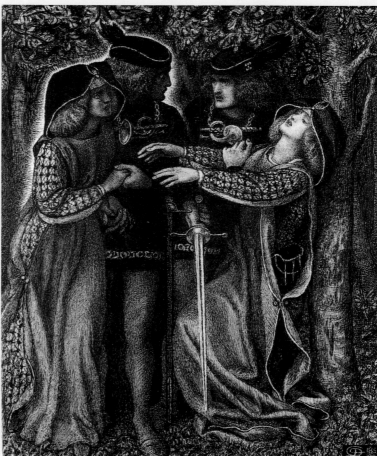

The young Algernon Swinburne in an 1861 watercolour portrait by Rossetti.

It had taken five years, until 1855, for Rossetti to introduce Lizzie to his family, and although they were nominally engaged, marriage terrified him: almost ten years after they had met it seemed as distant a prospect as ever. But in 1860, when Lizzie was ill and attempting to recover her strength at the Sussex resort of Hastings, Rossetti – perhaps sensing that she had not long to live – finally made the commitment she had sought since they met, and on 23 May, with no guests on either side, they were married. Lizzie recovered sufficiently to embark on a honeymoon in Paris (the intention to travel with Burne-Jones and his new bride Georgiana was thwarted when Burne-Jones, ever susceptible to stress-inducing occasions, fell ill). It was in Paris that Rossetti drew his haunting *How They Met Themselves*, an image that conveys a mood of impending death. In September Lizzie announced that she was pregnant, and for the first time in years her health seemed to improve.

In 1861 Rossetti became a shareholder in Morris's newly founded firm, and began contributing stained-glass designs. Then on 2 May Lizzie gave birth to a stillborn daughter. After their bereavement she became increasingly melancholy and subject to unpredictable behaviour, and was

How They Met Themselves, ominously drawn on the Rossettis' honeymoon.

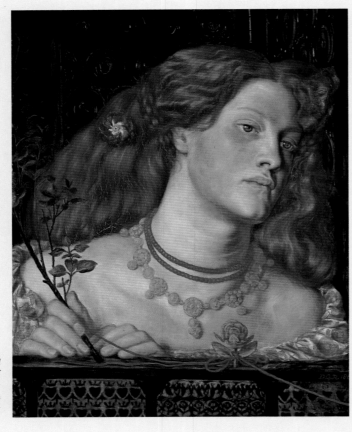

Fair Rosamund (1861), the mistress of Henry II, ironically modelled by Rossetti's own mistress, Fanny Cornforth.

taking increasing doses of laudanum, a powerful opiate. Rossetti was occupied with a number of projects: his translation *The Early Italian Poets from Ciullo d'Alcamo to Dante Alighieri…together with Dante's 'Vita Nuova'*, done when he was 20 and lately revised, was published; and he began work on illustrations for Christina's *Goblin Market*, which proved to be a success. (His curious caricature of the characteristically placid Christina in a tantrum, smashing ornaments and furniture, was produced as a punning reference to a review in *The Times* that used the phrase 'could not easily be mended'.)

Christina Rossetti jokingly depicted by her brother, 1862.

On the night of 10 February 1862 Rossetti dined in a restaurant with Lizzie and Swinburne. After leaving early and returning home with Lizzie, Rossetti went out again – perhaps to visit Fanny Cornforth. When he returned at 11.30, he found Lizzie unconscious, having apparently taken approximately ten times the fatal dose of laudanum. A doctor was called but was unable to save her, and at 7.20 on the morning of 11 February, Lizzie died. There seems little doubt that her overdose was deliberate, but an inquest returned a verdict of 'accidental death' (a common practice, to avoid the stigma of suicide).

While Lizzie's coffin lay open, Rossetti, obsessed

by the notion that he should have devoted more time to his wife's welfare than to his work, placed with her a notebook containing the sole complete collection of his poems (in emulation of a story by Christina, written 12 years earlier). Lizzie was buried at Highgate cemetery in the Rossetti family tomb; Christina Rossetti would be buried alongside her in 1894.

Rossetti spent the last 20 years of his life tormented with guilt and plagued by insomnia. With the poets Algernon Swinburne and George Meredith he moved to Tudor House, 16 Cheyne Walk, facing the Thames at Chelsea, where many notable artists lived, including Turner and Whistler. His was an eccentric household, his home filled with *objets d'art* and exotic animals, from his favourite wombats to kangaroos, as well as peacocks which proved so noisy that later leases prohibited tenants from keeping them. Although he gradually recovered some of his former *joie de vivre*, and was able to produce self-mocking caricatures such as one bewailing the death of one of his wombats, he became increasingly reclusive, only occasionally showing his work publicly, preferring to sell direct to a handful of dedicated collectors, and was extremely sensitive about criticism. Fanny Cornforth moved in with the euphemistic title of 'housekeeper', consolidating her role as mistress – which she had been, on and off, since they first met.

Rossetti's memorial to Lizzie, and effectively his last painting of her, was his *Beata Beatrix*. Thereafter his oil paintings became ever more sensuous and erotic, featuring loosely draped or naked women, typically with exaggerated masses of hair – a classic ingredient of the imagery

Rossetti's self-parodying *Death of a Wombat*, 1869.

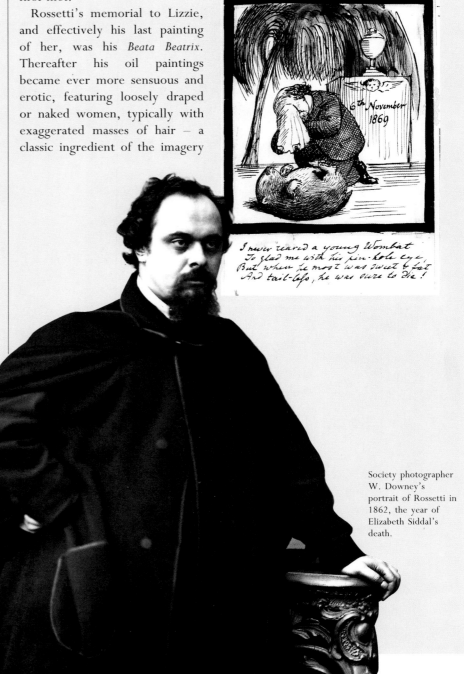

Society photographer W. Downey's portrait of Rossetti in 1862, the year of Elizabeth Siddal's death.

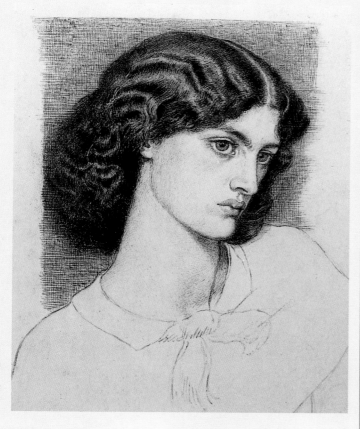

Jane Burdon drawn by Rossetti in 1858, the year before her marriage to William Morris.

'*Je n'en reviens pas* — she haunts me still. A figure cut out of a missal — out of one of Rossetti's or Hunt's pictures — to say this gives but a faint idea of her, because when such an image puts on flesh and blood, it is an apparition of fearful and wonderful intensity. It's hard to say whether she's a grand synthesis of all the Pre-Raphaelite pictures ever made — or they are a "keen analysis" of her — whether she's an original or a copy. In either case she is a wonder. Imagine a tall lean woman in a dress of some dead purple stuff, guiltless of hoops (or of anything else I should say), with a mass of crisp black hair, heaped into great wavy projections on each of her temples, a thin pale face, great thick black oblique brows, joined in the middle and tucking themselves away under her hair, a mouth like the "Oriana" in our illustrated Tennyson, a long neck, without any collar, and in lieu thereof some dozen strings of outlandish beads. In fine complete.'

Rossetti's relationship with her developed, apparently without complaint from William Morris. Meanwhile, his poetry experienced a resurgence when, inspired by Jane, he wrote a series of poems called *The House of Life*. In 1869 he decided to issue a collection of his unpublished poems, but although he had given copies of many to friends, he was unable to track most of them down, and it was with horror that he realized that the only complete collection was enclosed within Lizzie's coffin in Highgate cemetery. The only way to recover them was to have her body exhumed. After much procrastination he arranged for her disinterment — while he himself was away from

associated with the *femme fatale* — wearing sumptuous costumes and surrounded in almost claustrophobic proximity by decorative details that were a world apart from the simplicity of the medieval subjects that had preceded them. As Holman Hunt observed: 'He executed heads of women of voluptuous nature with such richness of ornamental trapping and decoration that they were a surprise, coming from the hand which had hitherto indulged itself in austerities.' These highly decorative later works have often been criticized, but Rossetti himself regarded them as his finest. In a letter of 21 October 1877 he wrote to Frederic Shields:

'I am quite certain that I have, as an artist should, made solid progress in the merit of my work, such as it is, and this chiefly within the last five years, during which I have supplied by application some serious qualities which had always been deficient in my practice, and produced, I will venture to say, at least a dozen works (among those covering the time) which are unquestionably the best I ever did.'

This transition was not without its rewards: by 1867 Rossetti was earning £3,000 a year, a substantial amount by the standards of the day. Yet he managed permanently to live beyond his means, and was eternally troubled. In 1868, while staying with William Bell Scott at the castle in Penkill, Ayrshire, that was the home of Scott's companion Alice Boyd, he seems to have considered suicide.

What kept him alive was his next great love — for Jane Morris. She began sitting regularly for him from the mid-1860s, and her distinctive visage can be seen in the paintings of his final years. As his photographs of her reveal, his canvases did not overstate Jane's beauty. The writer Henry James recalled:

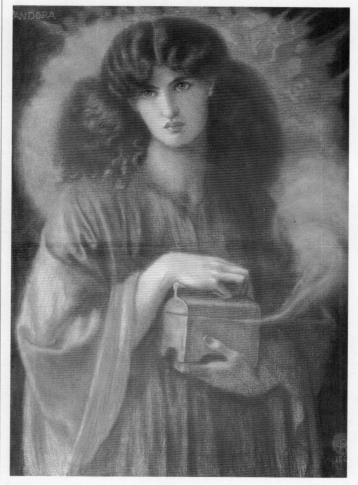

Pandora, a chalk study (1869) based on an 1865 photograph of Jane Morris.

London. The grisly task was managed by his friend and agent, the somewhat disreputable Charles Howell, and carried out on 5 October, by night and by the light of bonfires. According to Howell's imaginative description, Lizzie's body was 'perfectly preserved'; he even claimed that her luxuriant hair had grown so considerably after death that her tresses had to be cut to disentangle the book. He doused it in disinfectant, carefully separated the pages, and dried the volume. *Poems*, which included the sonnet 'Nuptial Sleep', was published to great acclaim in 1870, but its author experienced yet another wave of guilt for defiling Lizzie's grave. Suffering worse insomnia than ever, he began taking the newly invented hypnotic drug chloral hydrate, to which he rapidly became addicted.

His brother William Michael Rossetti and F. G. Stephens, two of the founding fathers of Pre-Raphaelitism, had both by then become respected critics, and both had naturally praised Rossetti's paintings and his poetry, a line that was generally followed by other reviewers. It therefore came as a shock when the success of his poems in 1870 was followed in 1871 by a vicious attack on the sensual elements of his work (with 'Nuptial Sleep' as a focus of the onslaught), published in an article entitled 'The Fleshly School of Poetry', by Robert Buchanan, writing pseudonymously as Thomas Maitland. In his weakened state Rossetti reacted with a sense of outrage and became convinced that he was the victim of a campaign of personal vilification and persecution. He retaliated with an article, 'The Stealthy School of Criticism' (*The Athenaeum*, 16 December 1871), and attempted to commit suicide by precisely the same method as Lizzie, but without success.

During the period from 1871–74 Rossetti shared the tenancy of Kelmscott Manor in Oxfordshire with William

Morris, while his relationship with Jane Morris continued (with the tacit consent of her husband). Jane Morris dominates Rossetti's late works, in which she appears in various guises, but generally as a powerful woman or a goddess. However, alarmed at his addiction and concerned for her children (one of whom had been discovered to be epileptic), she eventually terminated her relationship with Rossetti and returned contritely to her husband. She outlived William Morris (who died in 1896), dying in 1914.

Rossetti occupied himself during the remainder of the 1870s largely alienated from his friends, except Ford Madox Brown and Fanny Cornforth, his perception clouded by his intake of chloral, which he kept as secret as possible for fear that his reputation might be marred. In a letter to his friend Frederic Shields, he observed: 'As to the eternal drug, my dear Shields, if I suffer at times from morbidity, it is also possible for others to take a morbid view of the question... To reduce the drug as far as possibility admits is most desirable...but if an opinion were to get abroad that my works were subject to a derogatory influence which reduced their beauty and value, it would be most injuring to me.'

In 1882 he visited Birchington-on-Sea, a resort near Margate in Kent, with a new friend, Thomas Hall Caine, and there he died on Easter Day, 9 April. He was buried in the village in All Saints' churchyard with a Celtic cross monument designed by Brown, while memorial windows by Frederic Shields, based on one of Rossetti's own watercolours, *The Passover of the Holy Family: Gathering the Bitter Herbs* (Tate Gallery), were installed in the church.

Writing in the year of Rossetti's death, the critic William Tirebuck considered that many of his subjects were so obscure that 'his pictures not only require titles but footnotes'. His richly coloured medieval subjects, however, provided Pre-Raphaelitism with its distinctive identity, and the remarkable portraits of his later years stand alone as a highly charged and personal art. He has also been criticized for abandoning any attempt to deal with the social issues that were one of the stated tenets of the Pre-Raphaelite Brotherhood in favour of the aesthetic principle of 'art for art's sake'. In doing so he has been seen as a precursor of the Aesthetic Movement, and in works such as *Astarte Syriaca* as a pioneer Symbolist, thereby extending his influence into the twentieth century. In recent times his work has become increasingly appreciated, both aesthetically and commercially: the most expensive Pre-Raphaelite painting of all time is Rossetti's *Proserpine*, which sold in 1987 for £1,300,000, while a replica of *La Ghirlandata* was sold in 1993 for £420,000.

THE PLATES

1. THE GIRLHOOD OF MARY VIRGIN

2. ECCE ANCILLA DOMINI! (THE ANNUNCIATION)

3. THE FIRST ANNIVERSARY OF THE DEATH OF BEATRICE

4. FOUND

5. PAOLO AND FRANCESCA DA RIMINI

6. THE BLUE CLOSET

7. THE TUNE OF SEVEN TOWERS

8. THE WEDDING OF SAINT GEORGE AND THE PRINCESS SABRA

9. THE SEED OF DAVID

10. BEFORE THE BATTLE

11. THE SALUTATION OF BEATRICE

12. DANTIS AMOR

13. SAINT GEORGE AND THE PRINCESS SABRA

14. FAZIO'S MISTRESS

15. MORNING MUSIC

16. HOW SIR GALAHAD, SIR BORS AND SIR PERCIVAL
 WERE FED WITH THE SANC GRAEL; BUT
 SIR PERCIVAL'S SISTER DIED BY THE WAY

17. VENUS VERTICORDIA

18. IL RAMOSCELLO

19. THE BELOVED

20. REGINA CORDIUM

21. MONNA VANNA

22. SIBYLLA PALMIFERA

23. LADY LILITH

24. LA PIA DE' TOLOMEI

25. MARIANA

26. LA DONNA DELLA FIAMMA

27. DANTE'S DREAM AT THE TIME OF
 THE DEATH OF BEATRICE

28. VERONICA VERONESE

29. THE BOWER MEADOW

30. BEATA BEATRIX

31. LA GHIRLANDATA

32. PROSERPINE

33. SANCTA LILIAS

34. LA BELLA MANO

35. ASTARTE SYRIACA

36. THE BLESSED DAMOZEL

37. A SEA SPELL

38. A VISION OF FIAMMETTA

39. LA DONNA DELLA FINESTRA

40. THE DAY DREAM

PLATE 1

THE GIRLHOOD OF MARY VIRGIN
──────── 1848–49 ────────

Oil, 32¾ x 25¾ in / 83.2 x 65.4 cm
Tate Gallery, London

Executed when he was 20 years old, and shown at the Free Exhibition that opened on 24 March 1849, this was Rossetti's debut painting and the first to bear the P.R.B. initials in public. It was well received by critics and was sold for £80 to the Dowager Marchioness of Bath as a result of the intervention of Rossetti's aunt Charlotte Polidori, who had been her governess and was later her companion. The style is less naturalistic than the work of Rossetti's contemporary Pre-Raphaelite artists, being likened to 'Early Christian Art' by Ford Madox Brown. Brown supervised the painting with Holman Hunt, who shared Rossetti's Cleveland Street studio.

The Girlhood of Mary Virgin is steeped in religious symbolism. The seven-leaved palm branch on the ground is tied to a seven-thorned briar by a scroll, the inscription on which predicts the forthcoming Passion of Christ. There is a cross in the lattice work; a dove, symbolic of the Holy Spirit; and a red cloak representing the Robe of Christ. The vine signifies the sacrifice of Christ's life. The titles of the six large books stacked on the ground represent the three cardinal virtues and three of the theological virtues – although Justice was omitted. Rossetti explained the subject in an 1848 letter to his godfather Charles Lyell:

'The subject is the education of the Blessed Virgin, one which has been treated at various times by...other painters...they have invariably represented her as reading from a book under the superintendence of her mother, St. Anne... In order, therefore, to attempt something more probable and at the same time less commonplace, I have represented the future Mother of our Lord as occupied in embroidering a lily – always under the direction of St Anne; the flower she is copying being held by two little angels.'

The original intention to include two angels was rejected because of the problematic child model, and, as it was, the angel's head was repainted in July 1849. Christina, Rossetti's sister, sat for Mary; his mother for Saint Anne; and Old Williams, a family handyman, stood patiently in an uncomfortable pose with upraised arms as Saint Joachim. The identities of the figures are inscribed in gilt haloes above their heads. As portraits of the sitters, these were considered very accurate. Two sonnets, printed on gold paper, were attached to the frame of the picture and are now on the back. Amendments were made in 1864 when Rossetti borrowed the painting from its then owner, Lady Louisa Fielding, who was given it by her mother, the Marchioness of Bath.

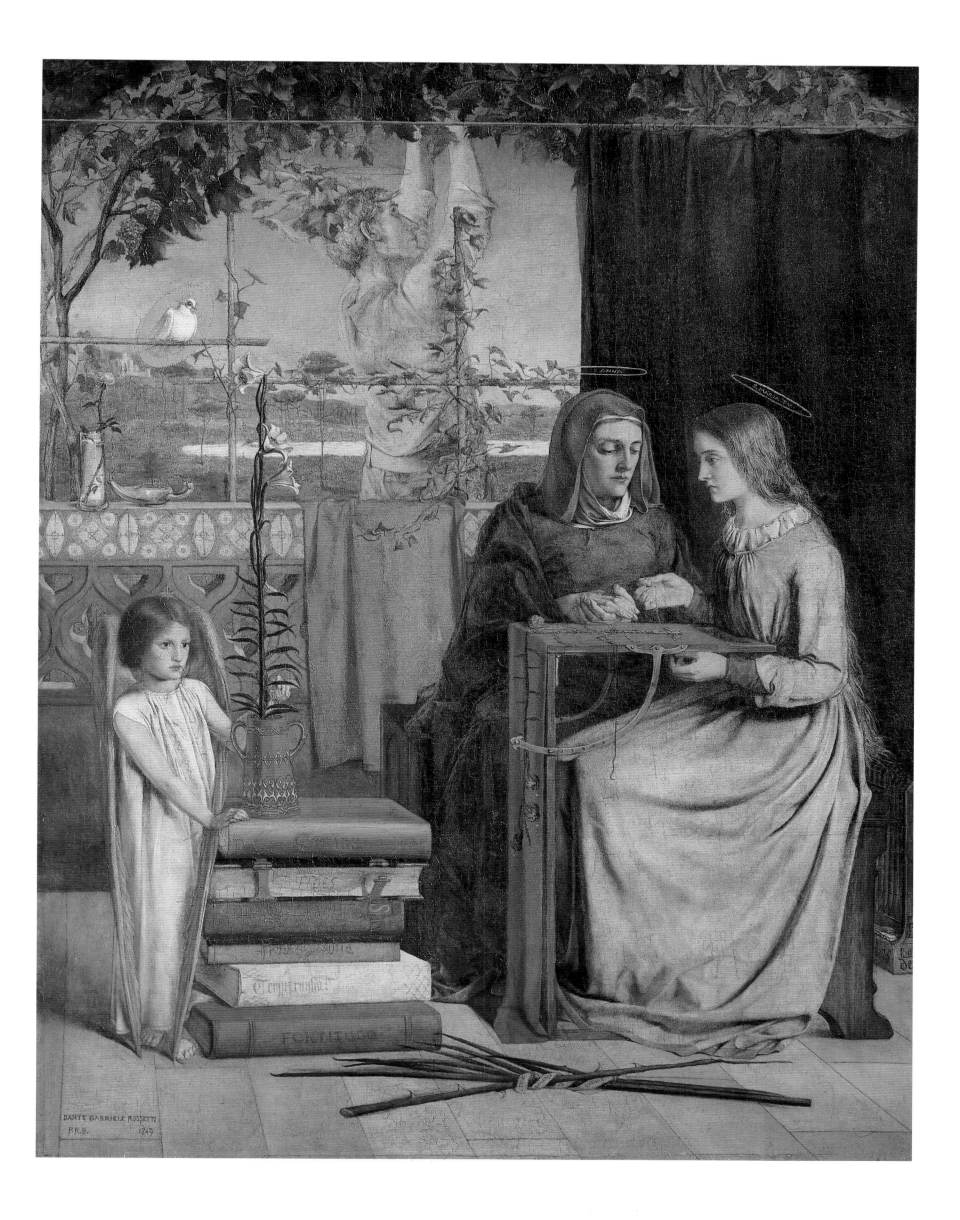

PLATE 2

ECCE ANCILLA DOMINI!
(THE ANNUNCIATION)
———— 1849–50 ————

Oil, 28⅝ x 16½ in / 72.7 x 41.9 cm
Tate Gallery, London

Rossetti's simplistic sequel to *The Girlhood of Mary Virgin* is stripped of its traditional grandiose iconography and its unaffected naïveté was admired by the other Pre-Raphaelites. The potentially risqué position of the Virgin on the bed without covers was justified in the context of the hot climate in which the composition is set. This painting contains the completed embroidery that Mary was working on in the previous work on the Mariological theme and was pre-empted by the lines of one of the sonnets on the frame of its predecessor:

> She woke in her white bed, and had no fear
> At all — yet wept till sunshine, and felt awed;
> Because the fulness of the time was come.

Christina Rossetti sat again for the Virgin in preparatory studies, but Rossetti later sought a red-haired woman to model, finding a Miss Love to sit for the hair. The archangel is a composite of various models employed by Rossetti, as well as his brother William.

The painting, which remained unsold during the next three years and was repeatedly amended, had been exhibited at the Portland Gallery in 1850 and received bitter public criticism. Rossetti's resulting outrage initiated a lifetime avoidance of public exhibitions, except on rare occasions, and a subsequent rejection of religious themes. In 1851 Lady Bath suggested, through Charlotte Polidori as an intermediary, that Rossetti should exhibit the painting in Liverpool, but he refused. The other members of the Pre-Raphaelite Brotherhood resented Rossetti for not exhibiting at the Royal Academy and for his consequent evasion of the storm of abuse that was directed at them. The title was later changed to *The Annunciation*, in fear of anti-Catholic recrimination, and it was eventually sold for £50 to an Irish Protestant shipping agent, Francis MacCracken (ungraciously described by Rossetti as 'an Irish maniac!'). It was sold at auction in 1874 for £388 10s, then in 1886 it was acquired by the Tate Gallery for £840.

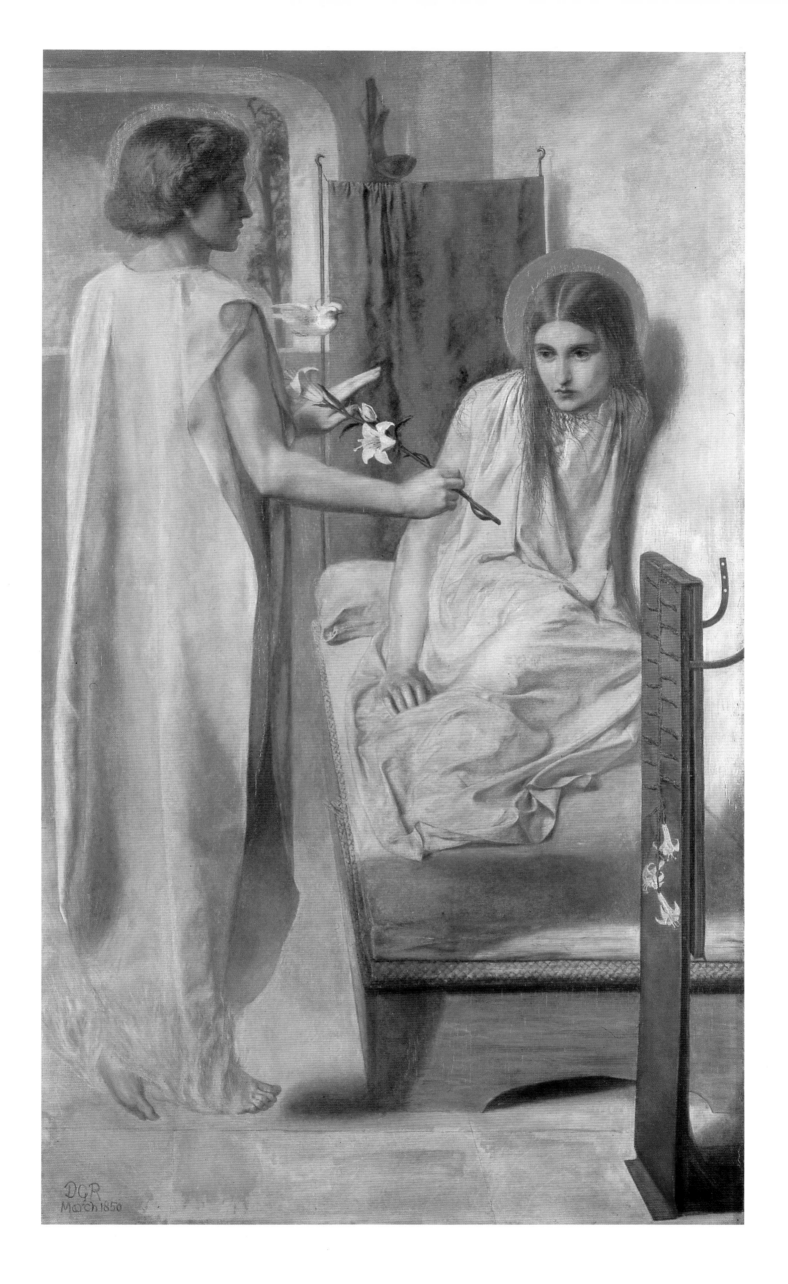

THE FIRST ANNIVERSARY OF THE
DEATH OF BEATRICE
—————————————— 1853–54 ——————————————

Watercolour, 16½ x 24 in / 41.9 x 61 cm
Ashmolean Museum, Oxford

This illustration to Dante's *Vita Nuova*, which Rossetti had completed translating in 1848, is his largest watercolour. It depicts Dante drawing an angel in memory of Beatrice, interrupted by sympathetic visitors. The subject-matter was explained in the inscription below:

'On that day on which a whole year has completed since my lady had been born into the life eternal, remembering me of her as I sat alone, I betook myself to draw the resemblance of an Angel upon certain tablets. And while I did this, chancing to turn my head, I perceived that some were standing beside me to whom I should have given courteous welcome and that they were observing what I did; also I learned afterwards that they had been there a while before I perceived them. Perceiving whom, I arose for salutation and said: "Another was with me."'

Lizzie Siddal posed for the young woman in her first subject modelled for Rossetti, and Old Williams for the elderly gentleman. Dante's features resemble those of William Rossetti. Rossetti's use of relatively dramatic chiaroscuro contrasts the sunlight with Dante's sombre gown and rich glowing drapery, and the influences of both Dürer and Memling can be seen. This painting was one of the works that became a catalyst for a second phase of Pre-Raphaelitism in the mid-1850s, inspiring Burne-Jones and William Morris. It was described by Ruskin, who first encountered Rossetti at this time, as 'a thoroughly glorious work – the most perfect piece of Italy, in the accessory parts, I have ever seen in my life'.

The angularity of the figures was characteristic of contemporary Pre-Raphaelite Brotherhood work, particularly that of Millais, the first owner of the picture. A greater attention to detail than in his earlier works is also clear. Rossetti had executed an earlier drawing of the same subject, finished in May 1849, that was compositionally very different; in the earlier version there was no female visitor. The woman in this version is probably intended to represent Gemma Donati, Dante's later wife, who appears again in Rossetti's *La Donna della Finestra*. Amongst the wealth of literary symbolism in the work, a crossbow, hanging on an easel next to a quill and ink bowl, represents Dante's active life, while the lute, skull and ivy symbolize *vanitas*.

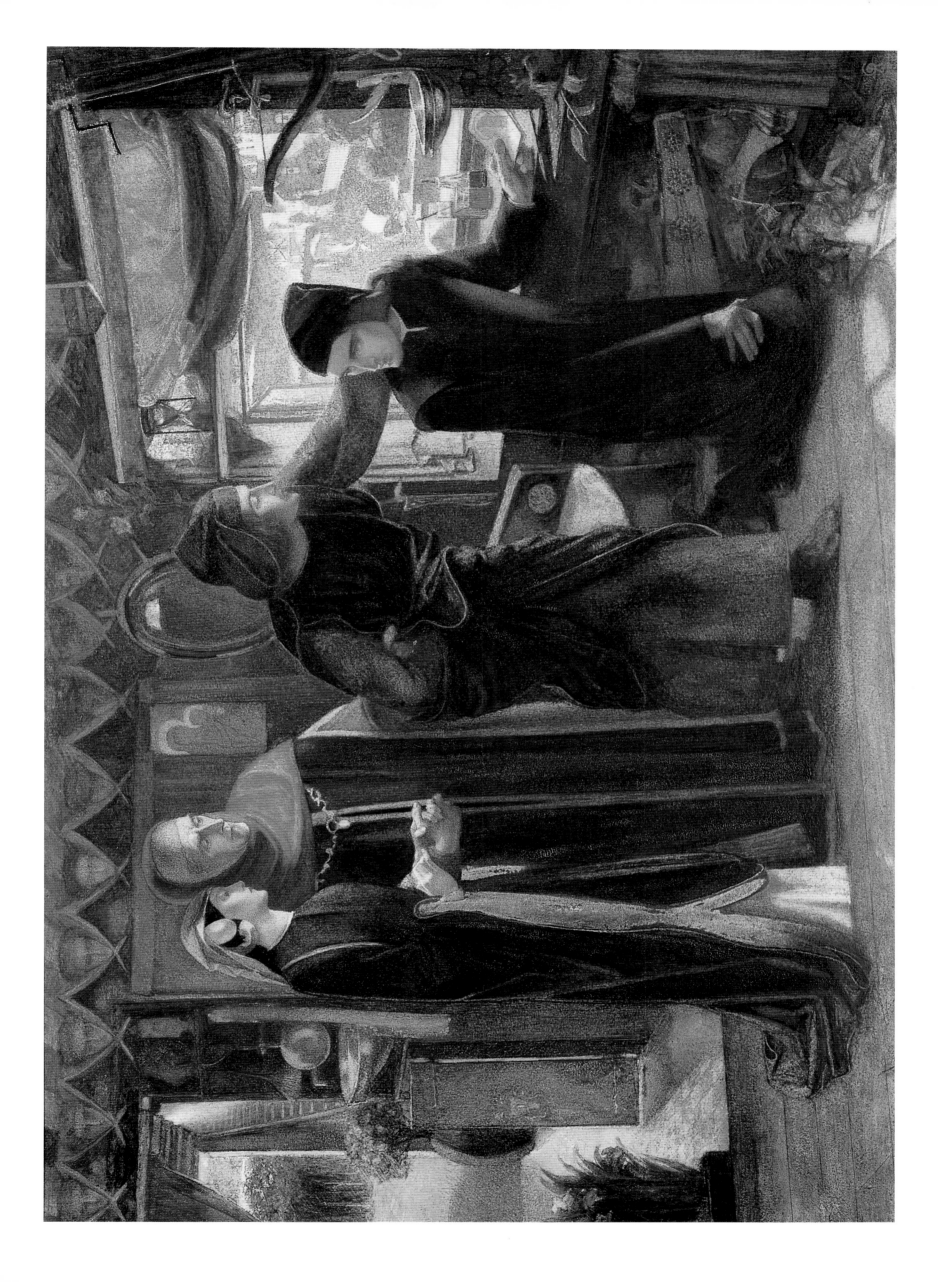

PLATE 4

FOUND

———————— 1854– (unfinished) ————————

Oil, 36 x 31¾ in / 91.4 x 80 cm

Delaware Art Museum: Samuel and Mary R. Bancroft Memorial

Rossetti, determined to paint a contemporary social subject, was preoccupied by *Found*, which remained unfinished, all his life. It was originally commissioned by MacCracken in 1854, then cancelled, and commissioned again in 1859 by James Leathart, a lead merchant in Newcastle. By 1867 the exasperated Rossetti was prepared to reimburse Leathart the money that he had advanced and relinquish the commission because so little progress had been made. Yet he took up the struggle again in both 1869 and 1879, hoping to prove that despite his being a poetic painter he was also able to paint naturalistic subjects. On Rossetti's death the incomplete painting entered the possession of William Graham, a Glasgow MP, who in 1869 had agreed to purchase *Found* for £800.

Rossetti's tackling the theme of the 'fallen woman' – a subject often treated in both literature and art by his contemporaries – indicated his untypically relaxed attitude toward sexuality in a climate of fervent morality. Prior to and during the execution of the painting, he wrote two poems on the subject. His *Jenny* of 1848 described an encounter with a prostitute – 'Lazy laughing languid Jenny / Fond of a kiss and fond of a guinea' – while his sonnet of 1881, written when he was completing the figures, speaks of the moment of truth captured by the painting, with the woman exclaiming, 'Leave me – I do not know you – go away!'

The choice of such an overtly moralistic theme reveals a dutiful attempt to follow the Pre-Raphaelite Brotherhood line on realism. F. G. Stephens analysed the imagery thus: 'the girl crouches against a wall of a church-yard – "where the wicked cease from troubling, and the weary are at rest"; the brightening dawn symbolizes, as it may be, peace (with forgiveness) on earth, or in Heaven, after sorrow.' The prostitute is discovered by a farmer, her former lover. Having executed the wall in situ in Chiswick, Rossetti spent much of the winter of 1854 with the Madox Browns in Finchley, where he laboured to paint the calf and cart. He wrote:

'As for the calf, he kicks and fights all the time he remains tied up, which is five or six hours daily, and the view of life induced appears to be so melancholy that he punctually attempts suicide at 3½ daily P.M.'

According to her own (and possibly fanciful) account – as told later to the painting's eventual owner, the American textile tycoon and collector Samuel Bancroft Jr – Rossetti, seeking a model for this painting, met Fanny Cornforth while out walking with friends. One of his party knocked her golden hair and sent it cascading down her back, and she was asked to sit for *Found* the next day. As she recalled it: 'he put my head against the wall and drew it for the head in the calf picture.'

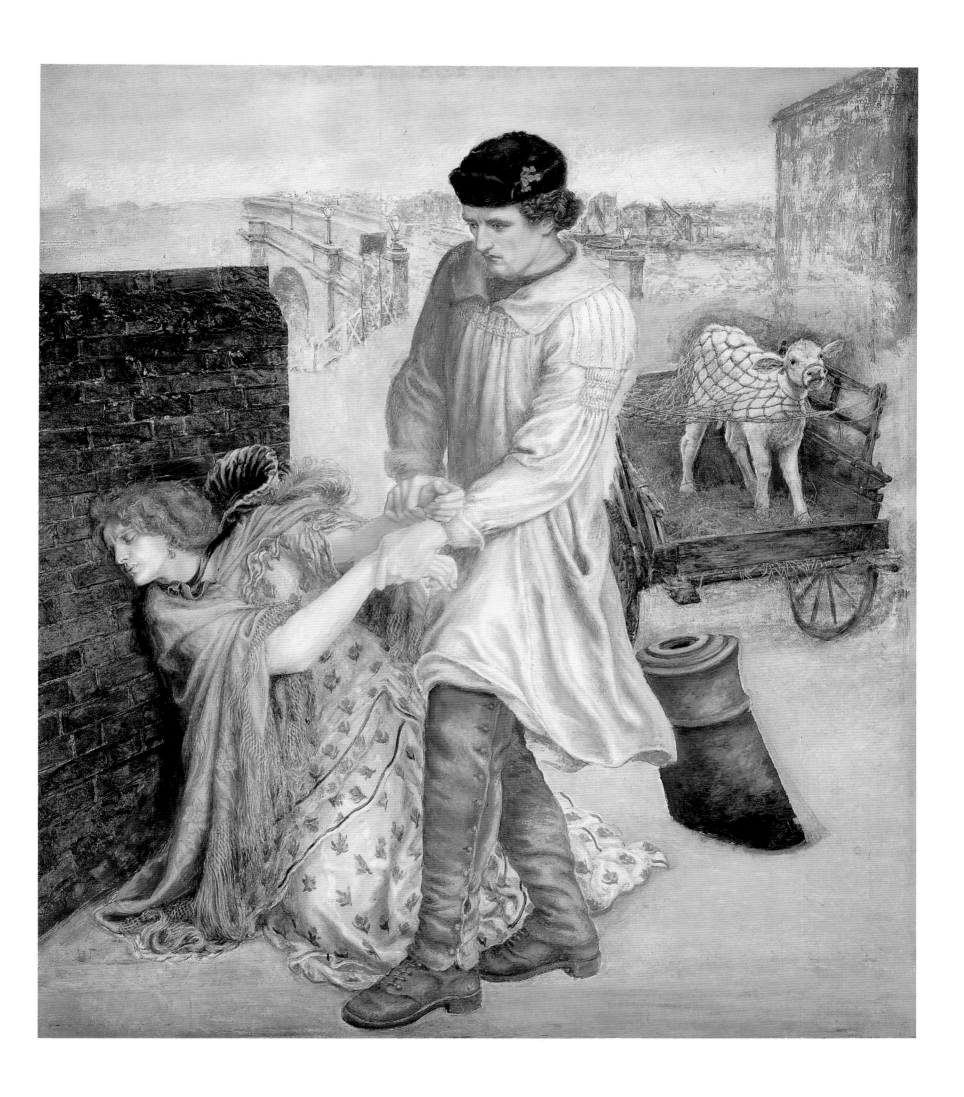

PAOLO AND FRANCESCA DA RIMINI
— 1855 —

Watercolour, 9³/₄ x 17¹/₂ in / 24.8 x 44.5 cm
Tate Gallery, London

This painting, illustrating a story from the fifth Canto of Dante's *Inferno*, depicts Francesca, who with her lover and brother-in-law Paolo Malatesta, was murdered by the Tyrant of Rimini. The depiction of the lovers reading was possibly inspired by the poem *The Story of Rimini* by Leigh Hunt. The composition is a three-part narrative beginning with the lovers' fatal kiss. In the centre, against a flat background, Dante and Virgil observe sympathetically as the entwined couple, on the right, float eternally through the flames of Hell. Based on preparatory studies made at least six years earlier, the work has a simplistic linearity, typical of early Pre-Raphaelite work.

Rossetti associated the tragic story with his own ill-fated relationship with Lizzie Siddal, who sat for Francesca. He painted three other versions of this subject in watercolour. This, the earliest version, has a particularly convoluted provenance. Later owned successively by William Morris and George Rae, a banker, it was originally bought by Ruskin for £35 after being hurriedly painted in just one week when Rossetti urgently needed money to relieve Lizzie, who was stranded penniless in Paris. Ruskin sent the watercolour with Rossetti's *Rachel and Leah* of 1855 to Ellen Heaton with the request that she choose either one. Miss Heaton selected *Rachel and Leah* (now in the Tate Gallery), probably under the moral guidance of Ruskin, who observed in November of that year that *Paolo and Francesca da Rimini* was 'a most gloomy drawing – very grand but dreadful – of Dante seeing the soul of Francesca and her lover!... Prudish people might perhaps think it not quite a young lady's drawing. I don't know. All the figures are draped – but I don't quite know how people would feel about the subject.'

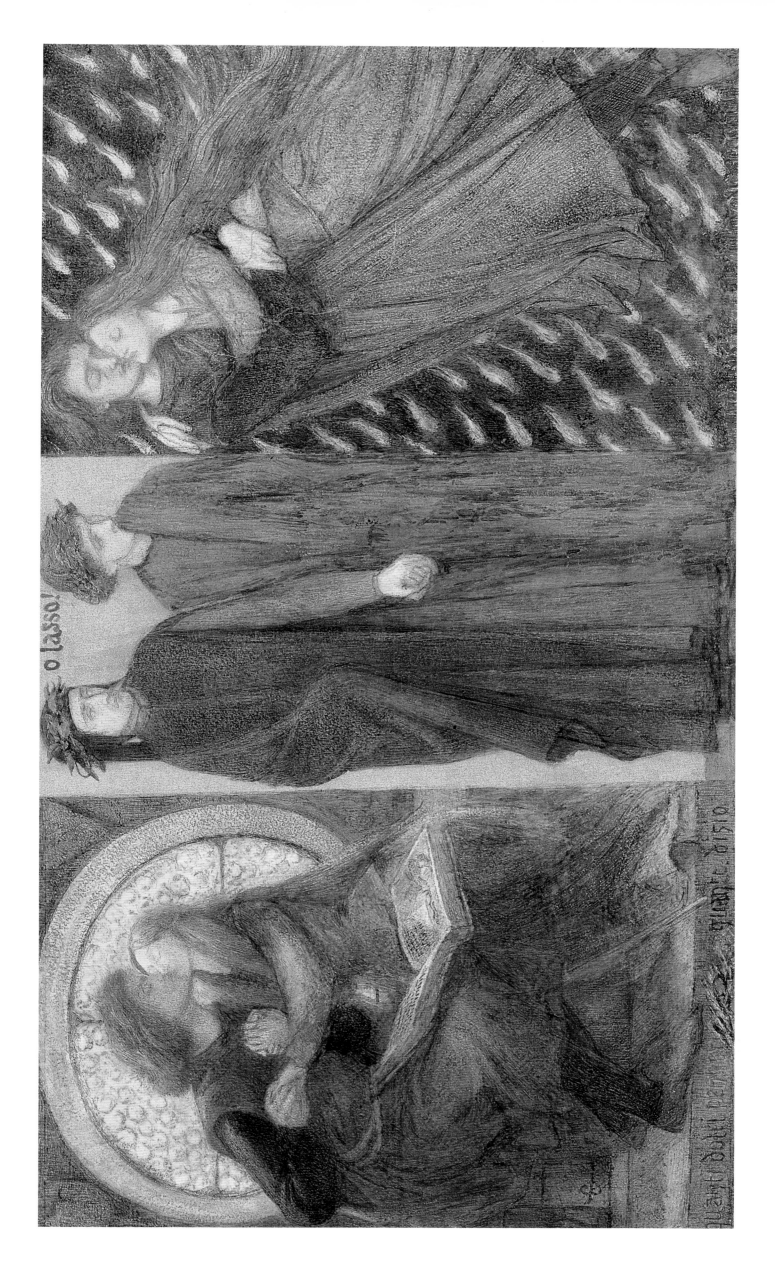

PLATE 6

THE BLUE CLOSET
———— 1856–57 ————
Watercolour, 13 1/2 x 9 3/4 in / 34.3 x 24.8 cm
Tate Gallery, London

Painted in the style of medieval illuminations, a number of Rossetti's watercolours of this period were inspired by medieval romances – predominantly those of Malory – and represent themes of ill-fated love. One such work, *The Blue Closet*, probably completed in late 1856 and exhibited at the Pre-Raphaelite show in Fitzroy Square in 1857, was one of five watercolours purchased by William Morris who commented 'These chivalric Froissartian themes are quite a passion of mine.' Rossetti, like many of his contemporaries, had a profoundly idealized view of the Middle Ages. This painting inspired Morris to write a poem of the same title, published the following year, in a collection entitled *The Defence of Guenevere*, which links the red lily in the foreground with death. At this time Rossetti's art and Morris's poetry were interdependent on each other for inspiration, Rossetti explaining that 'the poems were the result of the pictures, but don't at all tally to any purpose with them though beautiful in themselves.'

This watercolour depended predominantly upon colour and form for its meaning, as well as in its anticipation of musical subjects, and in this can be seen as a precursor to the Aesthetic Movement of the 1890s. Set in a brilliant blue-tiled chamber, it depicts two queens playing a clavichord with two attendants singing from sheet music. The symmetrical composition harks back to medieval scenes of musical angels, such as Orcagna's panel in Christ Church, Oxford. The sun and moon on the instrument, motifs common in Rossetti's work, refer to the passage of time. The holly on top of the clavichord indicates the time of year at which the picture was executed.

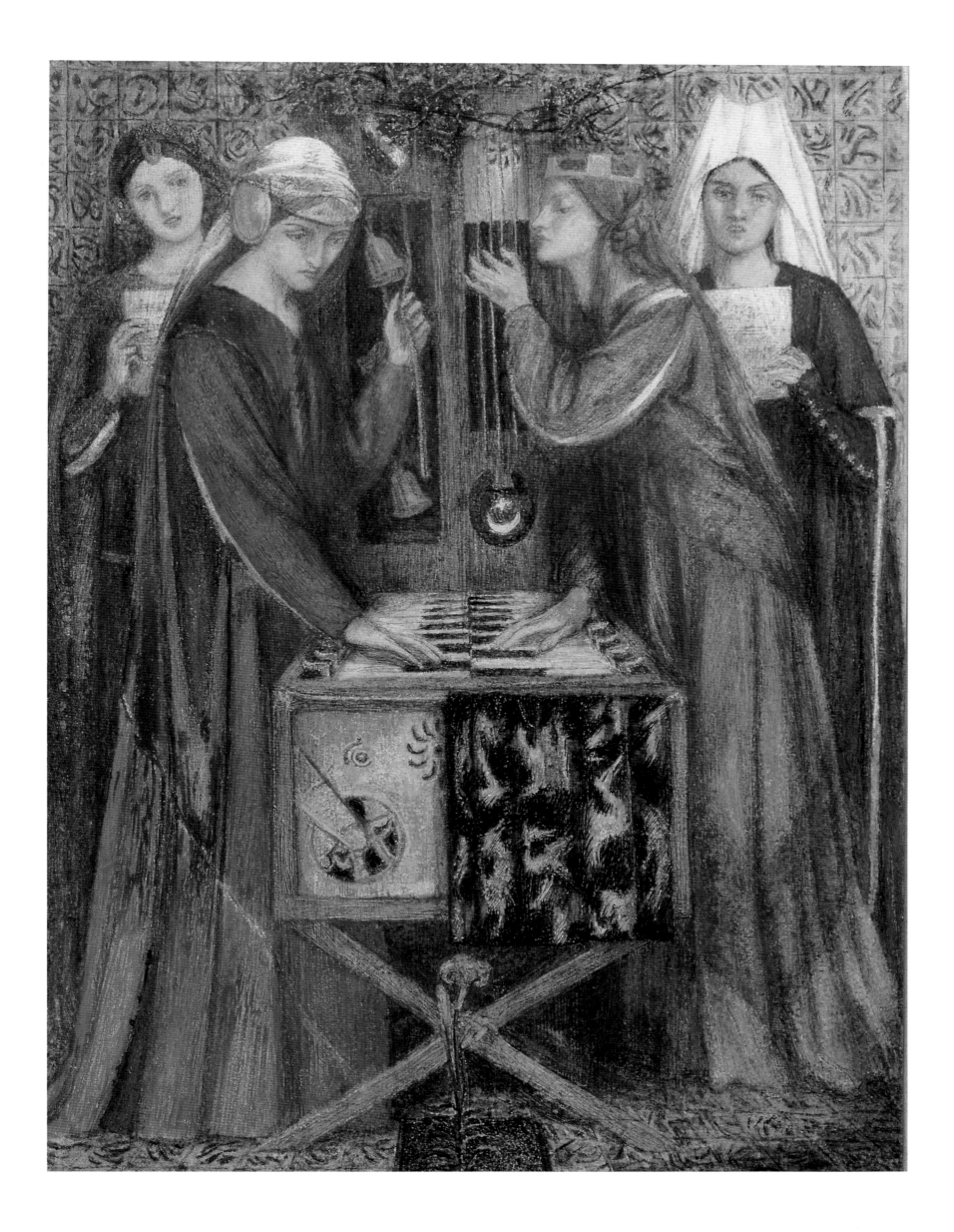

THE TUNE OF SEVEN TOWERS
————— 1857 —————
Watercolour, 12³/₈ x 14³/₈ in / 31.4 x 36.5 cm
Tate Gallery, London

Rossetti added strips to either side of this picture, initially a square composition, to make it rectangular. Still in its original frame, *The Tune of Seven Towers* is another of Morris's purchases that inspired a poem of the same name in his collection *The Defence of Guenevere*. The woman, modelled by Lizzie Siddal, sits in a tall oak chair playing an instrument that lies across her knees. The composition, divided diagonally by a banner, was derived from an 1853 drawing entitled *Michael Scott's Wooing*, but here the medieval setting is more complex and enigmatic. On the left an orange branch, symbolic of marriage, is placed on a bed by a maid. The meaning here is partly autobiographical. Rossetti, who was finally considering marriage, was anxious about Lizzie's potentially fatal illness, as indicated by the inclusion of the dove on the right, Rossetti's sign and pet name for her. The heroine wears a scallop shell around her neck, symbolizing pilgrimage and perhaps referring to Lizzie's travels in search of a cure. The pennant that hangs on the left is decorated by a border of a seven-towered castle, a motif echoed in gold on the top of the man's seat. The unusual medieval 'built-in' furniture was undoubtedly influenced by William Morris's aesthetic interests and the furniture made for his London showrooms in 1856. The subject may have been inspired by the contemporary relevance of the issues of medieval songs and tales such as Morris's favourite, the thirteenth-century courtly love story *Aucassin and Nicolette*.

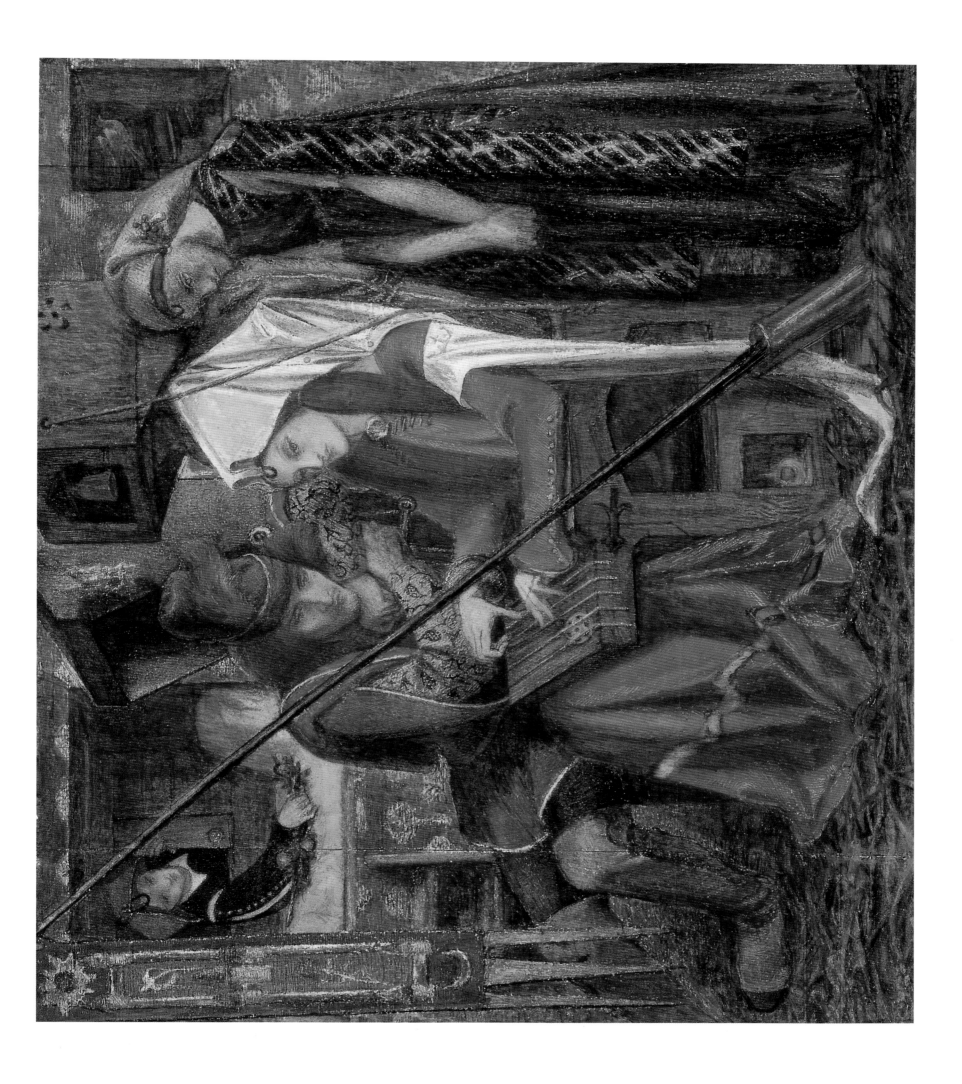

THE WEDDING OF SAINT GEORGE
AND THE PRINCESS SABRA

———————— 1857 ————————

Watercolour, 13¹/₂ x 13¹/₂ in / 34.3 x 34.3 cm
Tate Gallery, London

This picture was executed at a time of close contact with William Morris and Burne-Jones in Oxford, when marriage was particularly pertinent to all three men; Burne-Jones produced a stained-glass decoration on the same theme. Painted for William Morris, *The Wedding of Saint George and the Princess Sabra* is typical of Rossetti's work in this period in terms of its title, small scale, heraldic patterns and colouring, and the romantic theme taken from medieval literature. It was eventually bought by Thomas E. Plint, a Leeds stockbroker who was a patron of Ford Madox Brown.

As well as medieval manuscripts that Rossetti saw in the British Museum, and the collection owned by Ruskin, a source of inspiration could have been a ballad entitled *Sir George and the Dragon* in Thomas Percy's *Reliques of Ancient English Poetry* (1765):

> Therein with his dear love he liv'd
> And fortune did his nuptials grace:
> They many years of joy did see
> And led their lives at Coventry.

James Smetham, an artist on the periphery of the Pre-Raphaelite Brotherhood, described the painting as 'one of the grandest things, like a golden dim dream'. The claustrophobic composition is crammed with medieval motifs. Princess Sabra, enveloped in Saint George's arms, cuts a lock from her hair as he kisses her. Saint George, in profile, is enclosed in a series of right angles. Two angels, behind a hedge, play bells to the couple, perhaps luring them to the bed in the background.

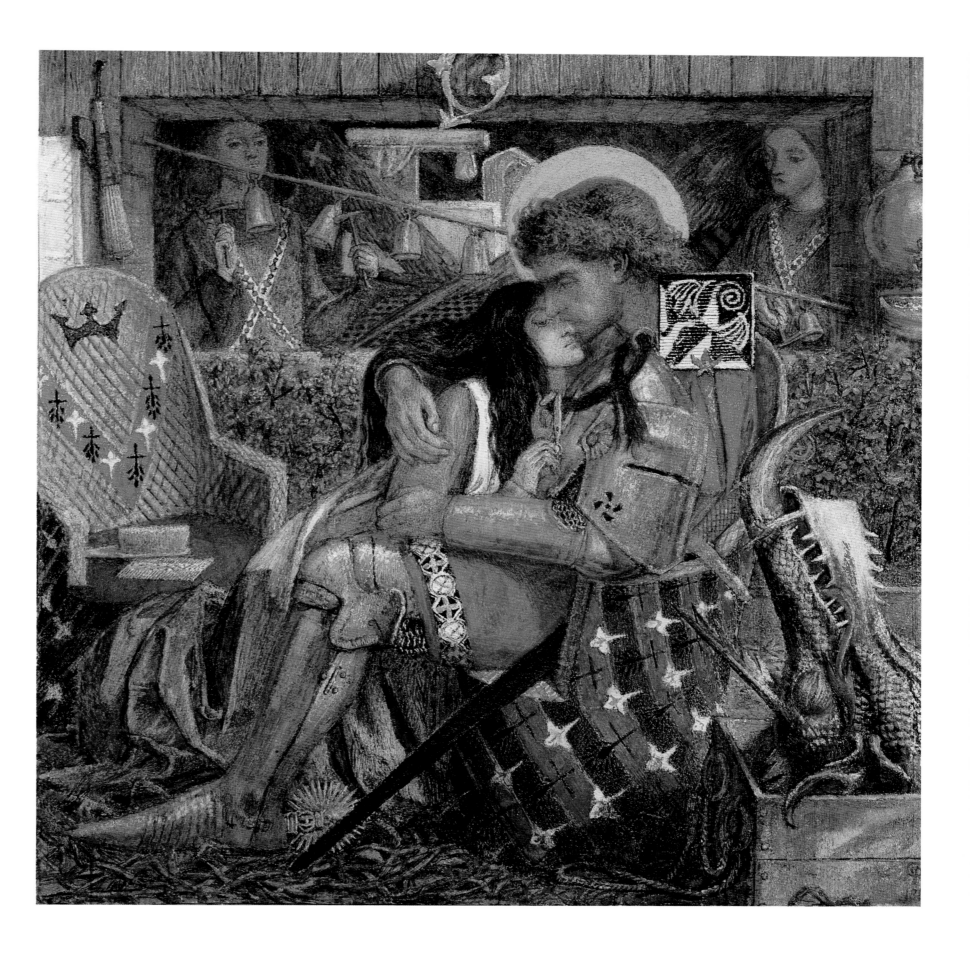

PLATE 9

THE SEED OF DAVID (TRIPTYCH)

——————————— 1858–64 ———————————

Oil, 90 x 60 in / 228.6 x 152.4 cm (centre);
73 x 24½ in / 185.4 x 62.2 cm (wings)
Llandaff Cathedral, Wales

In early 1856 Rossetti was commissioned by John P. Seddon, a friend of John Ruskin and the architect responsible for the restoration of Llandaff Cathedral, Wales, to paint an altarpiece for £400. Rossetti described the work, which heralded his move back to painting in oils, as 'a big thing which I shall go into with a howl of delight'. In painting the only Pre-Raphaelite work that related directly to their Italian predecessors – specifically Veronese's *Adoration of the Magi* of 1573, which had been acquired by the National Gallery in 1855 – Rossetti used the traditional triptych composition with a central nativity scene. Tintoretto's *Nativity* of 1581 was possibly a source of inspiration, as well as his *Annunciation* of 1583–87, although Rossetti explained that: 'The centrepiece is not a literal reading of the event of the Nativity, but rather a condensed symbol of it.'

The work was first executed in watercolour in 1856, and there is a vast difference in size, technique, style and composition in the final oil version completed eight years later. The figures in the watercolour were in Rossetti's medieval style in contrast to the figures in the oil painting, all of whom are more monumental and with a more developed musculature. The semi-nude David in the left panel is almost classical in his contrapposto pose, his body having been modelled by Timothy Hughes, Fanny Cornforth's husband, and the head by William Morris. Swinburne sat for the king and Burne-Jones for the shepherd, while Arthur Hughes's daughter Agnes modelled for the child. The Virgin's body was based upon Fanny Cornforth; her head was originally copied from Ruth Herbert but was changed to depict Jane Morris in 1861.

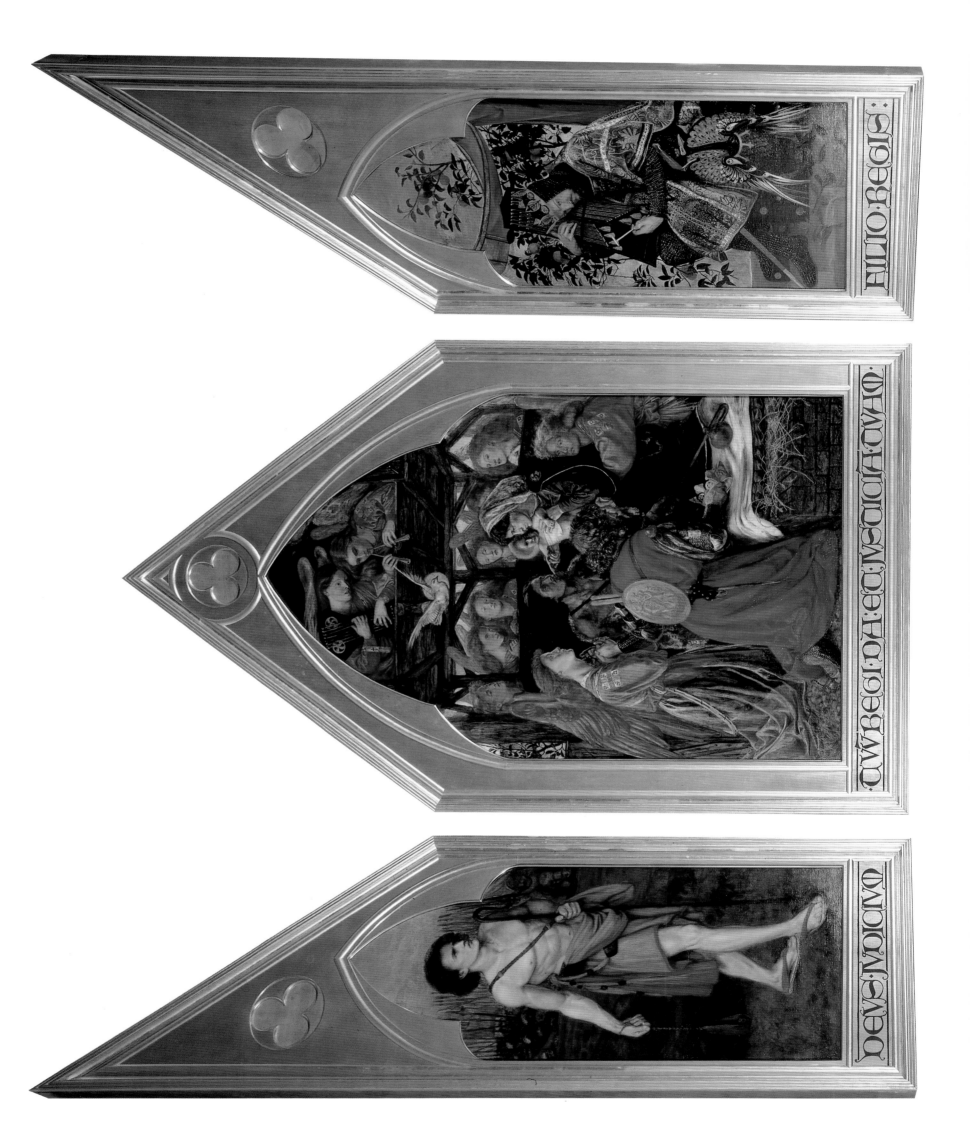

PLATE 10

BEFORE THE BATTLE
—— 1858 ——
Watercolour, 16⅝ x 11 in / 42.5 x 28 cm
Special Picture Fund, Courtesy Museum of Fine Arts, Boston

Before the Battle was commissioned in 1858 and purchased for £50 by Charles Eliot Norton of Harvard University. The original drawing for the piece was probably completed when Rossetti was staying with Lizzie at Matlock in 1857. Two years earlier Lizzie herself had painted a watercolour of a woman attaching a pennant to a knight's lance (*Lady Affixing a Pennant to a Knight's Spear*, 1856, Tate Gallery). Rossetti sent his completed picture four years later, having retouched it under the guidance of Ruskin, who was concerned about the artist's reputation in the United States. Ruskin wrote to Norton in 1862:

'Rossetti was always promising to retouch your drawing and I, growling and muttering, suffered him still to keep it by him in the hope his humour would one day change. At last it has changed; he has modified and in every respect so much advanced and bettered it... It is exceedingly full and interesting in fancy, and brilliant in colour.'

In his diary Ford Madox Brown made the following observation about Rossetti's paintings of this period:

'They form an admirable picture of the world of our fathers with its chief characteristics — religion, art, chivalry and love. His forte, and he seems to have found it out, is to be a lyrical painter and poet, and certainly a glorious one.'

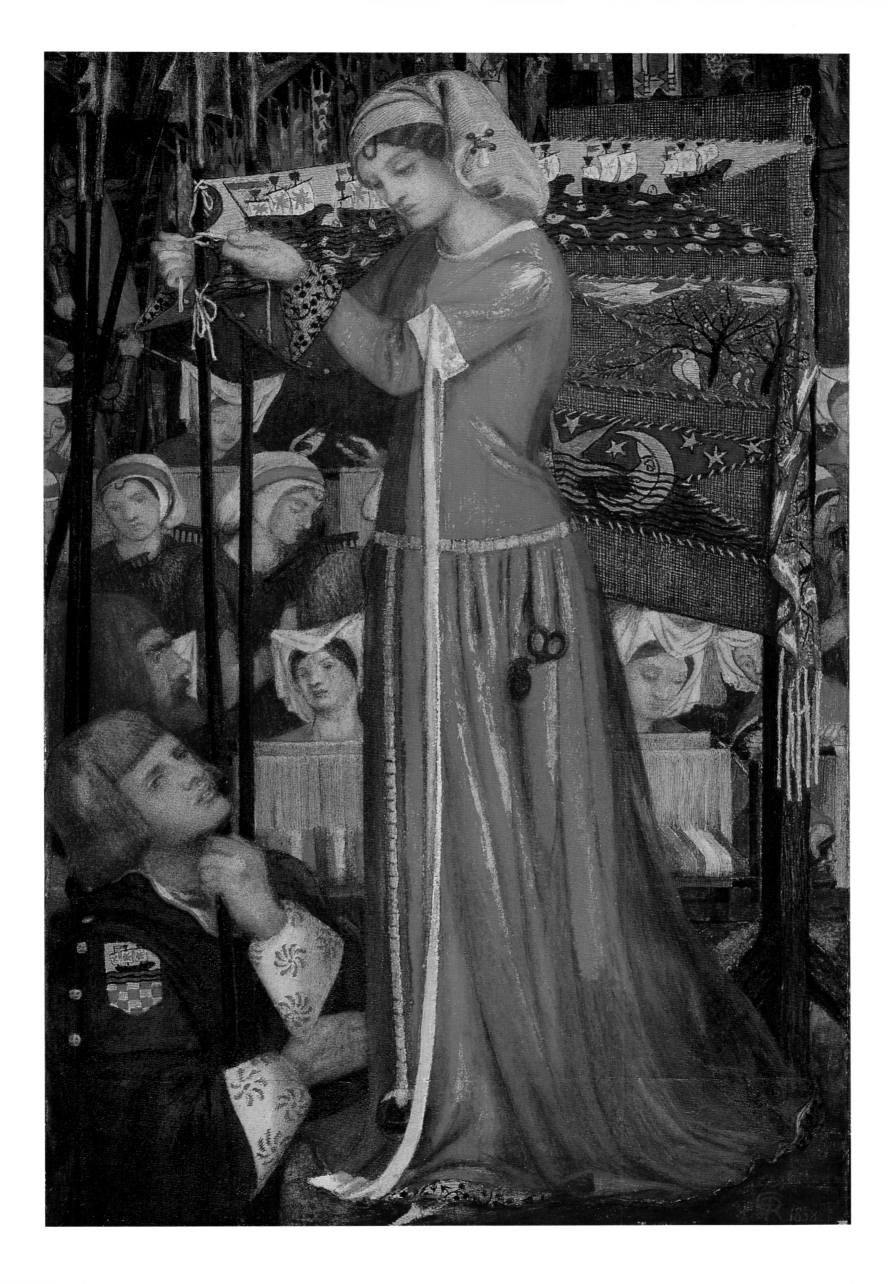

PLATE 11

THE SALUTATION OF BEATRICE
—————————— 1859 ——————————

Oil on two panels, both 29½ x 31½ in / 74.9 x 80 cm
National Gallery of Canada, Ottawa

This work consists of two panels that originally decorated a settle in Morris's Red House, painted between 16 and 25 June 1859, and which were brought together in a frame designed by Rossetti when the house was abandoned in 1865. The first panel portrays the first meeting of Dante and Beatrice in Florence, as described in Dante's *Vita Nuova*, and was modelled by Jane Morris, Fanny Cornforth and Mary, Morris's housekeeper at Red Lion Square in London. Underneath, Rossetti added a quotation from a sonnet in the *Vita Nuova*: 'My lady carries love within her eyes.' A gold figure on the frame between the panels, symbolizing love, holds a sundial whose shadow is cast at nine o'clock, the time of Beatrice's death. Love extinguishes the flame of his torch to symbolize her death, the date of which, 9 June 1290, is inscribed above. The second panel depicts Dante's meeting with Beatrice in Eden, as described in the *Divine Comedy*, accompanied by the inscription 'Guardami ben: ben son, ben son Beatrice', meaning 'Look on me well: I indeed, I indeed am Beatrice.' Rossetti wrote: 'The subjects are treated from the real and not the allegorical side of Dante's love story.'

Commissioned by Richard Leyland, the Liverpool shipowner who also owned Whistler's celebrated Peacock Room, Rossetti began a later version in 1880 that remained unfinished at his death and was acquired by Leyland. In a letter of February 1881 Rossetti told Jane Morris: 'It seems to enchant everyone who sees it.'

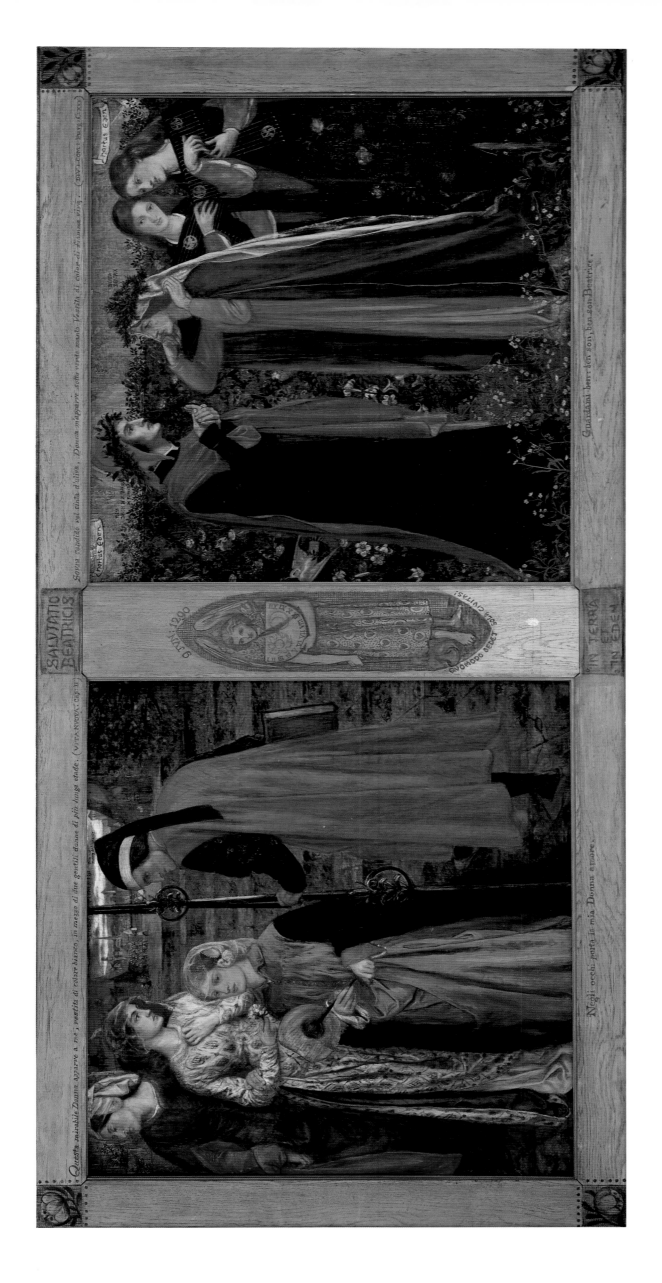

PLATE 12

DANTIS AMOR
———— 1859–60 ————
Oil, 29 1/2 x 32 in / 74.9 x 81.3 cm
Tate Gallery, London

Dantis Amor was originally a third central panel to decorate the settle at Red House, placed between *Dante Meeting Beatrice in Florence* and *Dante Meeting Beatrice in Paradise*. The panels were separated a few years after execution, the other two possibly being sold to raise capital for Morris's new firm. Another theme from Dante, it portrays a red-haired angel, here symbolizing love, holding a sundial and bow and arrow. Christ's head on the left is the sun in contrast to Beatrice encircled by the moon. This central panel symbolizes Beatrice's death, the transition between earth and heaven. Rossetti's message here is that love is the generating force of the universe. The combination of the inscriptions around the sun and moon form the concluding words of the *Vita Nuova*, translated as: 'That blessed Beatrice who now gazeth continually on His countenance, who is through all ages blessed.' The inscription that separates night and day was taken from the *Divine Comedy*: 'Love who moves the sun and the other stars.' Rossetti connected this with Dante's vision of Love in the *Vita Nuova*. Some authorities have suggested that only the heads in this unfinished composition were executed by Rossetti himself.

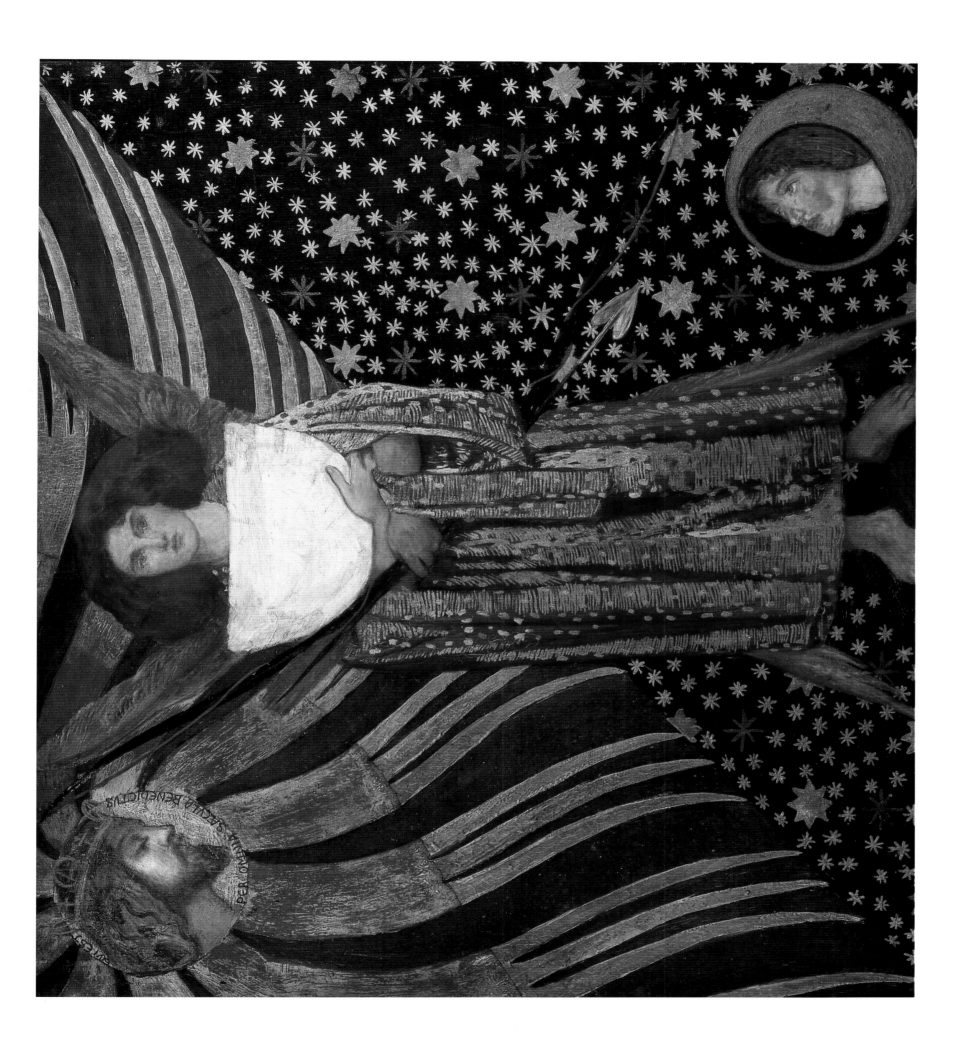

SAINT GEORGE AND THE PRINCESS SABRA
——————— 1862 ———————
Watercolour, 20⅝ x 12⅛ in / 52.4 x 30.8 cm
Tate Gallery, London

In late December 1861 Rossetti had begun a watercolour for Ellen Heaton that had been delayed as a result of Lizzie's poor health. Lizzie had continued to sit for him until early February of the following year while he made several studies, but shortly afterwards she died tragically of a laudanum overdose. Here Saint George washes his hands, having slain the dragon. A crowd (seen through the window) gathers outside, triumphantly carrying the dragon's head. Rossetti, anxious about this vignette in the composition, wrote to Miss Heaton:

'I trust you will not be disappointed with the out-of-window bit, which however is not very bright in effect. Being altogether in one corner, & no bright colour occurring anywhere else in the picture, it would hardly have been practicable without endangering the balance of the light & shade, to have adopted an effect…where the outdoor light is central.'

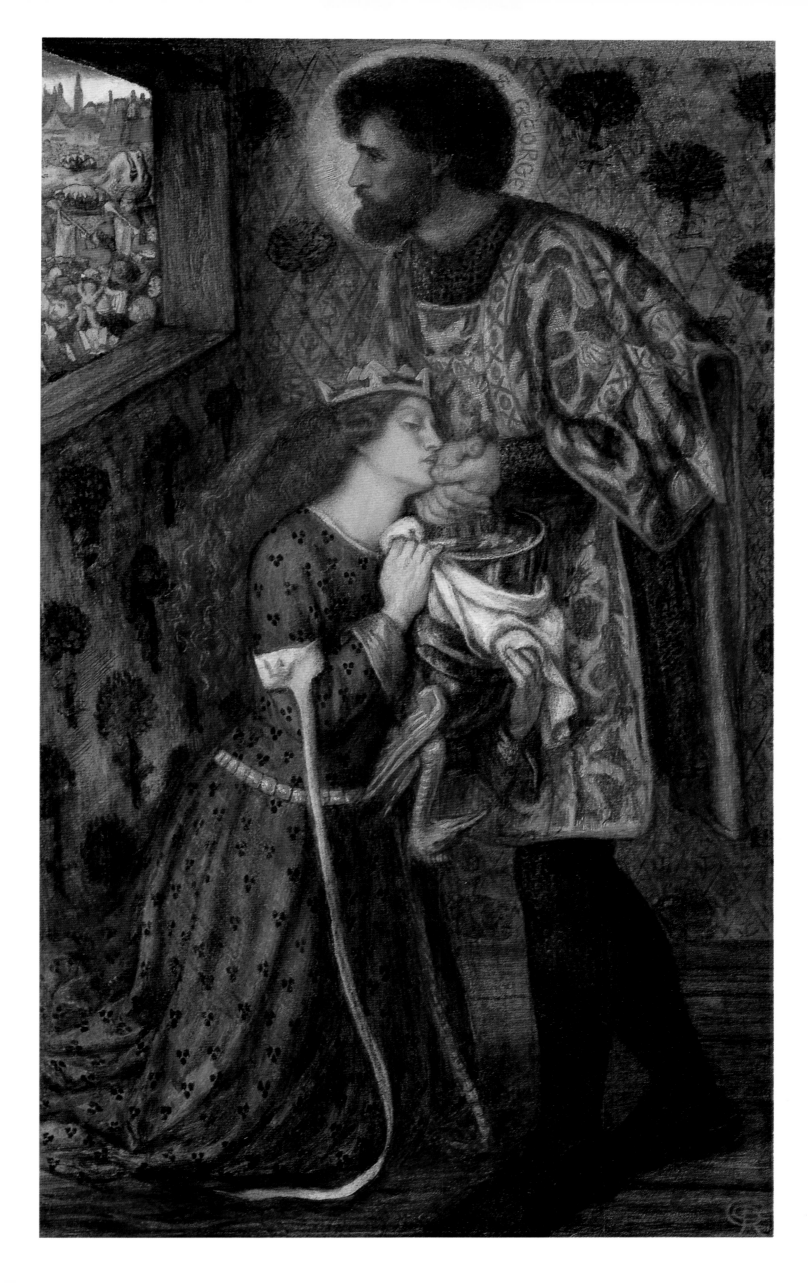

PLATE 14

FAZIO'S MISTRESS
— 1863 —
Oil, 17 x 15 in / 43.2 x 38.1 cm
Tate Gallery, London

Begun in 1863, this oil was primarily a study in colour and shows Fanny Cornforth plaiting her hair. Ten years later it was substantially retouched, glazed and given the additional title *Aurelia*. Rossetti wrote to Fanny at that time:

'I have got an old picture of you here which I painted many years ago. It is the one where you are seated doing your hair before a glass. Rae [the banker George Rae], to whom it belongs, has sent it me as it wants some glazing, but I am not working at all on the head, which is exactly like the funny old elephant [Rossetti's nickname for her], as like it as any I ever did.'

Fazio's Mistress is one of a group of Venetian-inspired bust-length paintings from this period, the culmination of which was his *Lady Lilith* of 1864–68. The title was taken from a poem by Fazio degli Uberti that described the seductive beauty of his lover. This allure, seen in all Rossetti's paintings of this group, is manifested in her sensual mouth, white neck and voluptuous arms. Titian's *Alphonse Ferrara et Laura de Dianti* in the Louvre was particularly influential, but as well as this precedent, links can be seen in the drapery of Whistler's contemporary work. Rossetti began this oil as 'chiefly a piece of colour'.

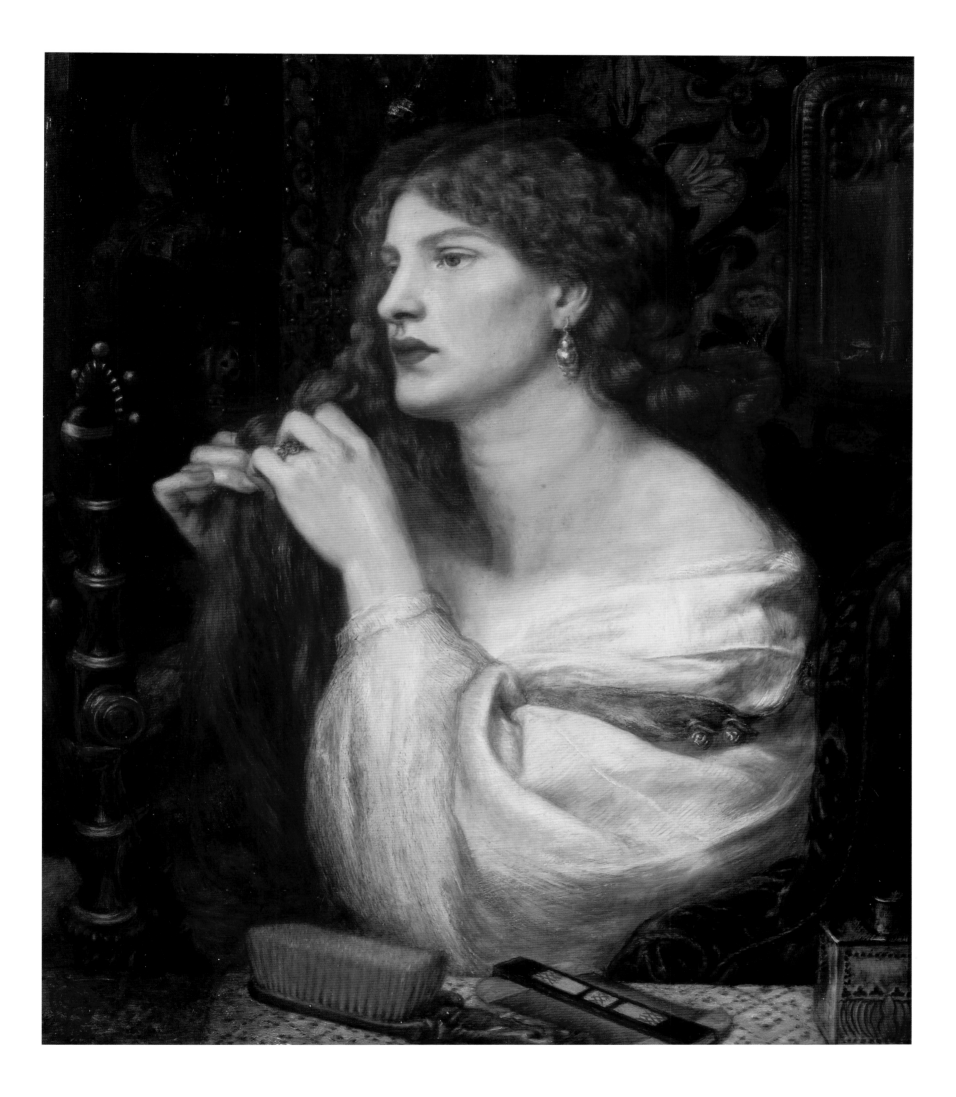

PLATE 15

MORNING MUSIC
—————— 1864 ——————
Watercolour, 11⅝ x 10½ in / 29.5 x 26.7 cm
Fitzwilliam Museum, Cambridge

The subject of this watercolour, a beautiful woman having her hair dressed to musical accompaniment, harks back to Rossetti's earlier works such as *A Christmas Carol* of 1857–58. Like *Fazio's Mistress*, however, this picture is infinitely more sensual, and here again the use of colour is predominantly white with brilliant touches of gold, blue and red, in line with the Venetian model. William Etty's painting *The Duet*, shown at the International Exhibition of 1862, may also have been an influence. Like his friend Swinburne, Rossetti believed that art should be sensually gratifying, and in his group of 'toilette' paintings his commitment to 'art for art's sake' is highly apparent and in contrast to the founding ideals of the Pre-Raphaelite Brotherhood. Rossetti gained decadent literary inspiration from Fitzgerald, Baudelaire, de Sade, and Gautier, the last of whom wrote in his preface to *Mademoiselle de Maupin*: 'enjoyment seems to me to be the end of life, and the only useful thing in the world. God has willed it so. He who created women, perfumes and light, lovely flowers, good wives, lively horses.'

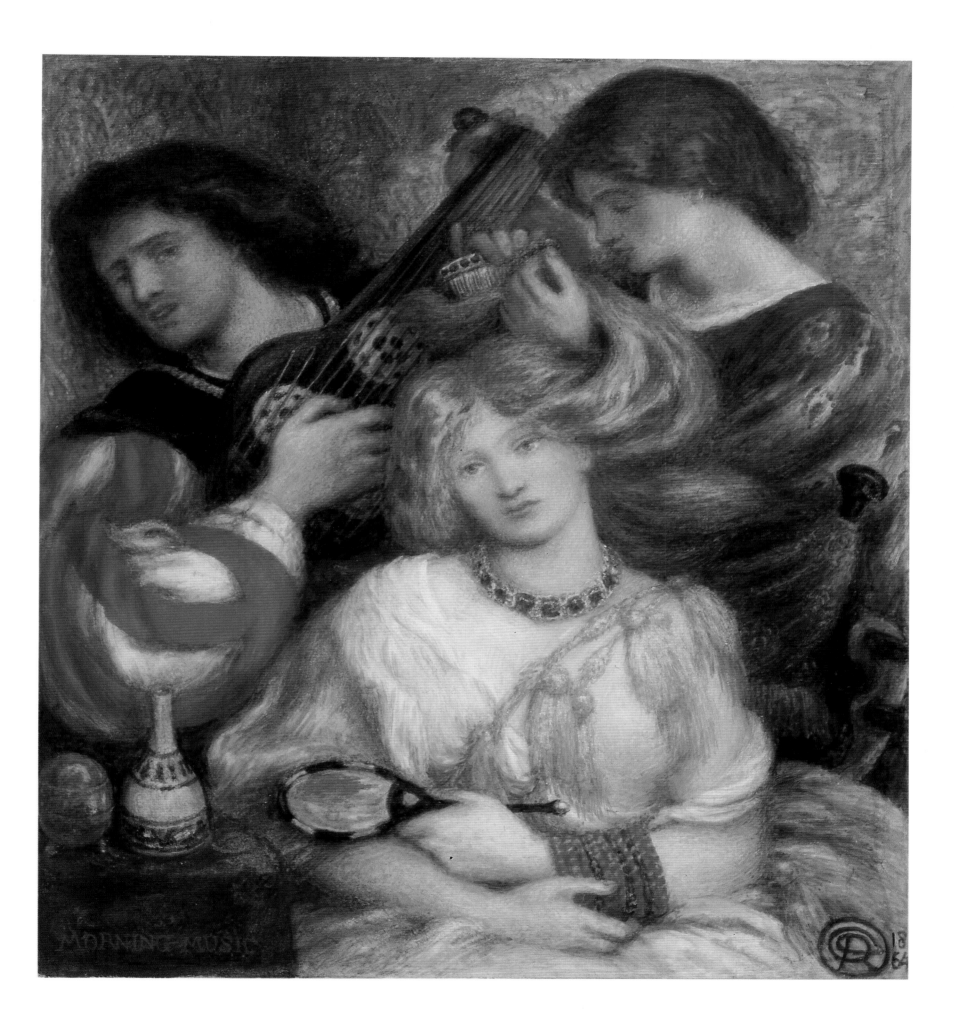

PLATE 16

HOW SIR GALAHAD, SIR BORS AND SIR PERCIVAL WERE FED WITH THE SANC GRAEL; BUT SIR PERCIVAL'S SISTER DIED BY THE WAY

———— 1864 ————

Watercolour, 11¹/₂ x 16¹/₂ in / 29.2 x 41.9 cm
Tate Gallery, London

The design of one of Rossetti's most brilliant medieval watercolours was based on the mural *The Attainment of the Sanc Grael*, painted for the Oxford Union in 1857. It was commissioned by Ellen Heaton, to whom Rossetti wrote in late June 1864:

'Its price is, as we agreed, 100 guineas; and I would be much obliged if you could kindly let me have £55 (the remainder going to discharge my too long outstanding debt) on the day of your visit, as I am obliged to go out of town…for a day or two, to avoid a summons on the Grand Jury(!) which would otherwise absorb my time & annihilate my olfactory nerves for a month to come.'

He succeeded in realizing in watercolour the colours he had striven for unsuccessfully in the Oxford murals, and the composition is similar to that of *Sir Galahad, Sir Bors and Sir Percival Receiving the Sanc Grael*, incorporating a row of red-haired, crimson-winged angels, with Sir Galahad modelled by Swinburne, whom Rossetti met during the murals enterprise.

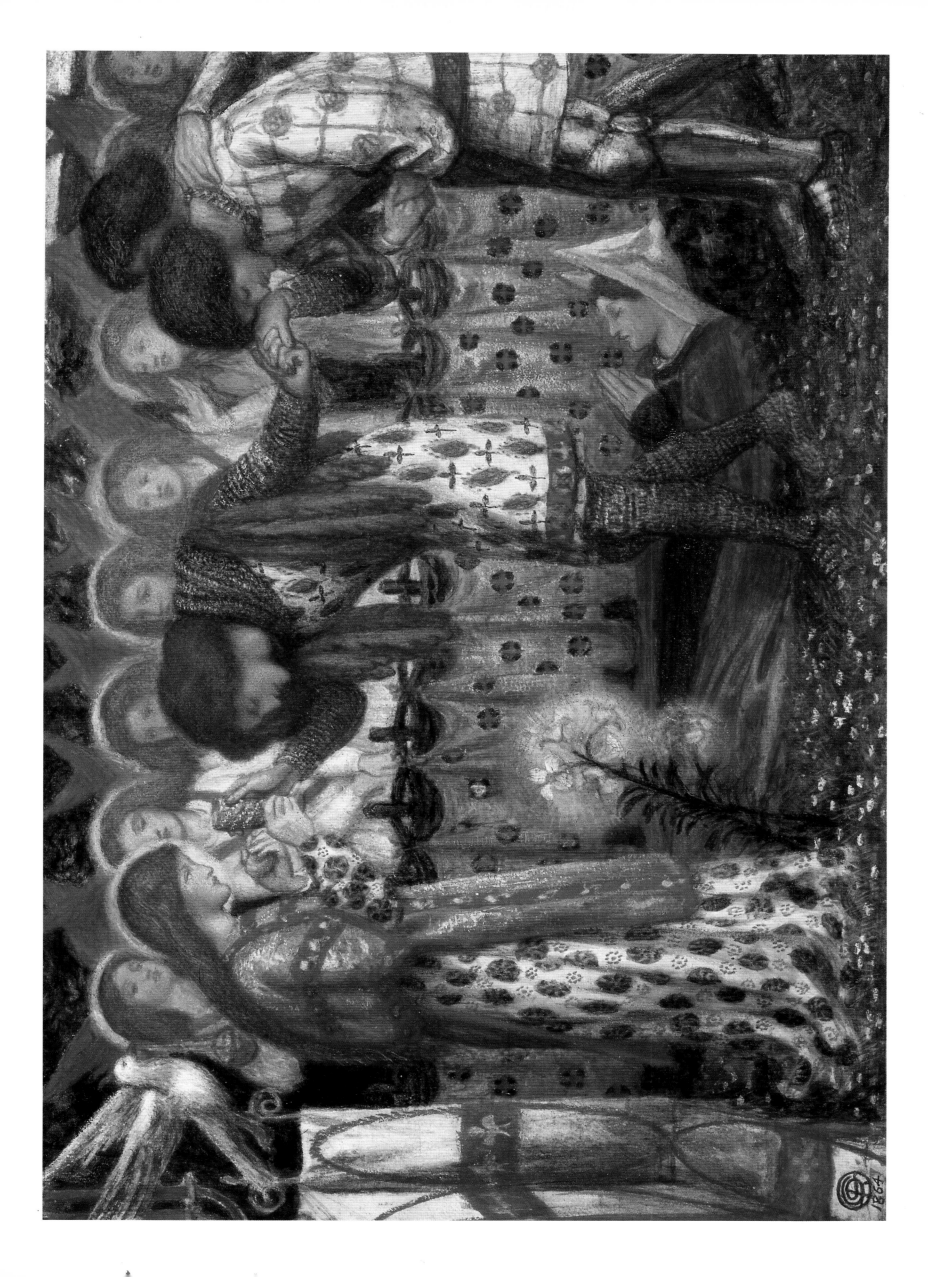

PLATE 17

VENUS VERTICORDIA
—— 1864–68 ——

Oil, 38⅝ x 27½ in / 98.1 x 69.9 cm
Russell-Cotes Art Gallery and Museum, Bournemouth

Commissioned by John Mitchell of Bradford, this is one of very few nudes painted by Rossetti. He did several versions of the subject, including a watercolour for William Graham in 1868. That version was based on his 1863 chalk study modelled by a statuesque cook whom he had noticed in the street, whereas this final version in oil, repainted in March 1867, was modelled by Alexa Wilding, a dressmaker whom Rossetti 'discovered'.

Venus is surrounded by honeysuckle and roses, her auburn hair topped by a halo. Rossetti struggled with the flowers, having difficulty in finding exactly what he wanted at a fair price. Ruskin, appalled by the sensuality of the painting, but too prudish to voice the precise subject of his complaint, condemned the coarseness of the flowers. One of Rossetti's patrons, Graham Robertson, wrote later to a friend:

'I suppose he is reflecting upon their morals, but I never heard a word breathed against the perfect respectability of a honeysuckle. Of course roses have got themselves talked about from time to time, but really if one were to listen to scandal about flowers, gardening would become impossible.'

Rossetti wrote a sonnet on the same subject:

> She hath the apple in her hand for thee,
> Yet almost in her heart would hold it back;
> She muses, with her eyes upon the track
> Of that which in thy spirit they can see.
> Haply, 'Behold, he is at peace,' saith she;
> 'Alas! the apple for his lips,—the dart
> That follows its brief sweetness to his heart,—
> The wandering of his feet perpetually.'
>
> A little space her glance is still and coy;
> But if she give the fruit that works her spell,
> Those eyes shall flame as for her Phrygian boy.
> Then shall her bird's strained throat the woe foretell,
> And her far seas moan as a single shell,
> And her grove glow with love-lit fires of Troy.

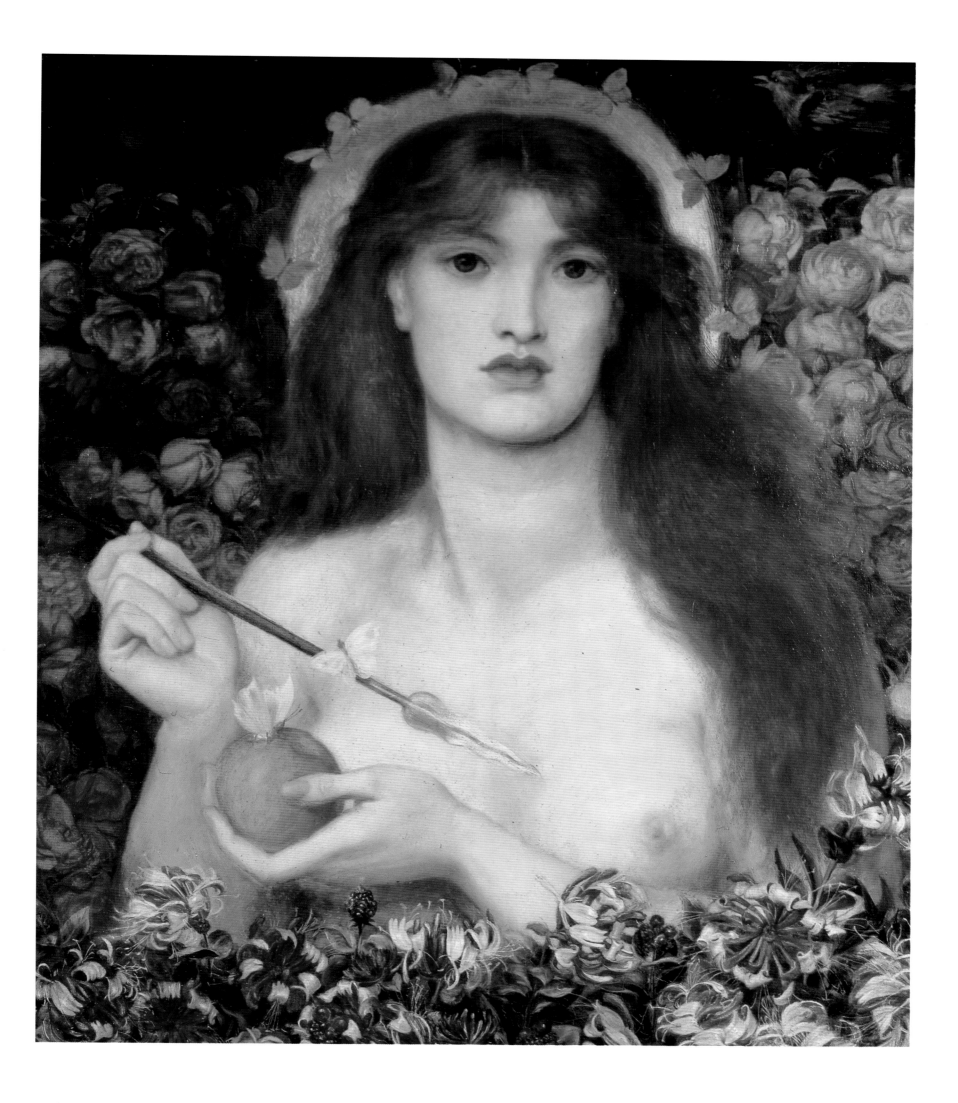

PLATE 18

IL RAMOSCELLO
——— 1865 ———

Oil, 18¾ x 15½ in / 47.6 x 39.4 cm
Harvard University Art Museums, Fogg Art Museum,
Bequest of Grenville L. Winthrop

F. G. Stephens was one of the founding members of the Pre-Raphaelite Brotherhood and later became the art critic of *The Athenaeum*. Rossetti, in an attempt to control the criticism of his work, gave Stephens exclusive rights to describe his major paintings and Stephens's writing provided Rossetti with a vehicle for his own interpretations of his work to become known. On 21 October 1865 Stephens reviewed Rossetti's contemporary work including *Il Ramoscello*:

'Of late, the artist in question has, to some extent, resumed that practice of oil painting; the results we have now to describe, in the hope that the public may, ere long, be able to judge for itself of the order of their invention, originality and technical merit. The scale of the pictures is almost that of life.'

According to William Rossetti, *Il Ramoscello* was a portrait of William Graham's daughter Amy, later Lady Muir MacKenzie. It was originally known by the title of *Belle e Buona* but was renamed in 1873 when Rossetti borrowed and repainted much of it, adding the new title to the background. Graham had most of the amendments removed but left the new title.

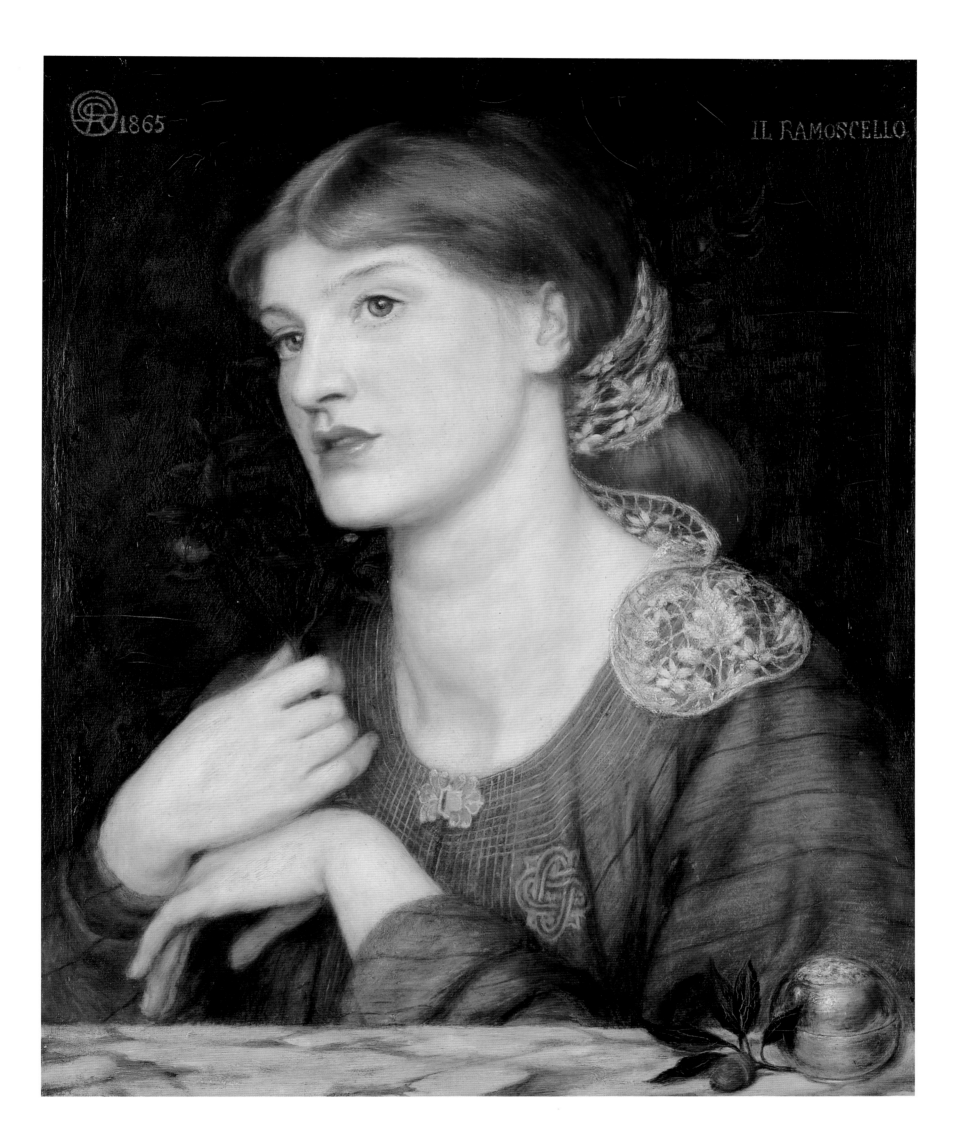

PLATE 19

THE BELOVED
—— 1865–66 ——

Oil, 32½ x 30 in / 82.6 x 76.2 cm
Tate Gallery, London

Commissioned by George Rae in 1863 for £300 and also known as *The Bride*, this painting is an elaborated version of *The Blue Bower* and was initially intended to be a Beatrice for Ellen Heaton. However, the colouring of the model, Marie Ford, resulted in a change of concept to the Bride of the Canticles (in the biblical 'Song of Solomon'). In July 1863 Rossetti wrote to Miss Heaton:

'The model does not turn out to be a perfect Beatrice, and at the same time I do not like to risk spoiling the colour by altering it from another model. I have got my model's bright complexion, which was irresistible, & Beatrice was pale... I propose to find another subject to suit the figure – the Bride from Solomon's Song is specially in my head... The present Beatrice must, I now find, be turned without remedy into Solomon's Bride, which however is a subject I myself delight in and have always had an eye to.'

Here a bride, about to meet her groom, is surrounded by five attendants in a composition that consciously recalls the setting of a jewel. The woman on the right was Keomi, the gypsy mistress of the painter Frederick Sandys. In March 1865 a mulatto girl on the left was replaced by a black boy, Rossetti explaining: 'I mean the colour of my picture to be like jewels and the jet would be invaluable.' This change could have been influenced by Manet's *Olympia*, which Rossetti may have seen on a visit to Manet's Paris studio in 1864. The painting was substantially retouched in 1873. The less glossy surface may indicate the beginning of Rossetti's descent into drug and alcohol abuse. The elaborate frame, probably also dating from 1873, is inscribed with an erotic quotation from the 'Song of Solomon' that accentuates the sensual intensity of the painting:

> My Beloved is mine and I am his.
> Let him kiss me with the kisses of his mouth:
> for thy love is better than wine.
> She shall be brought unto the King
> in raiment of needlework: the virgins
> that be her fellows shall bear her
> company, and shall be brought unto thee.

F. G. Stephens praised the then incomplete painting in *The Athenaeum*:

'The subtle rendering of expression, upon which the picture relies for much of its effect, is admirable, and thoroughly original in its tenderness. The beautiful drawing...would be remarkable in a production of any school, and is still more so in that of England, where thoroughness and respect is rare indeed.'

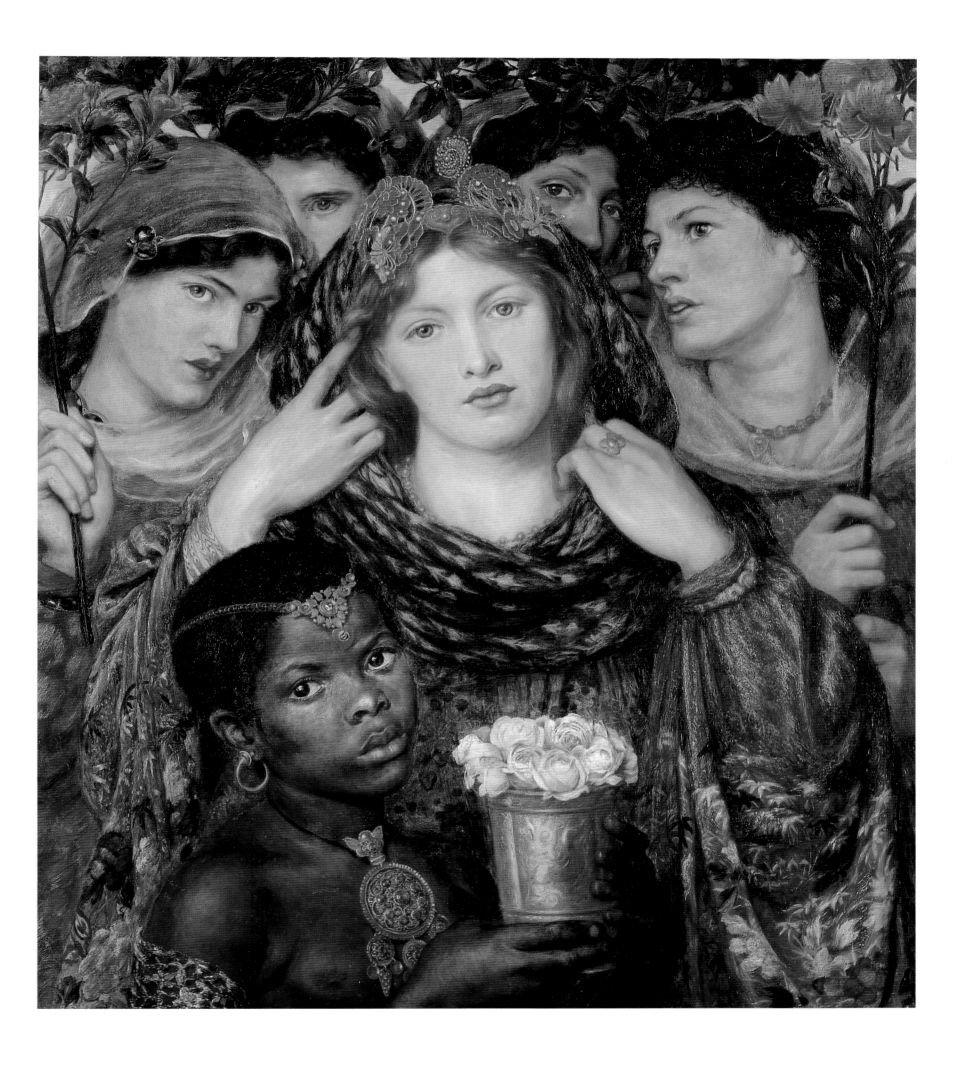

PLATE 20

REGINA CORDIUM
——— 1866 ———
Oil, 23½ x 19½ in / 59.7 x 49.5 cm
Glasgow Museums: Art Gallery and Museum, Kelvingrove

On their honeymoon in Paris in 1860 Lizzie had sat for studies for an oil portrait on a panel with the same title, on which Rossetti later based this version of *Regina Cordium*, for which Alexa Wilding sat. This is one of the last in the artist's group of luxuriant bust-length pictures of women in confined spaces. The title, which is inscribed on the painting, allowed Rossetti to depict a beautiful young woman with emblems of love, contrasting nature and artifice. Naturalistic roses in the foreground are juxtaposed with stylized flat plants on the parapet. On the gold background there is a heart-shaped medallion of a cupid in a blindfold. This subject may have been influenced by Bellini's *Doge Loredan* or Van Eyck's *Leal Souvenir*, both of which were bought by the National Gallery in the mid-nineteenth century. In an 1858 letter to William Bell Scott, Rossetti wrote:

'Even among the old good painters, their portraits and simpler pictures are almost always their masterpieces for colour and execution, and I fancy if one kept this in view one must have a better chance of learning to paint at last.'

The 1860 version of *Regina Cordium* (which is translated as *The Queen of Hearts*) is a study in pinks and reds that has the quality of a playing-card with a decorative scheme of hearts and kisses. Its first owner was probably Ruskin. The *Regina Cordium* of 1866 was painted for J. Hamilton Trist, a Brighton wine merchant, and sold for £170. Ironically the painting – which is currently still in its original frame – was at one stage owned by Fanny Cornforth who, at the time of the honeymoon, was ill in London, distraught as a result of Rossetti's marriage to Lizzie.

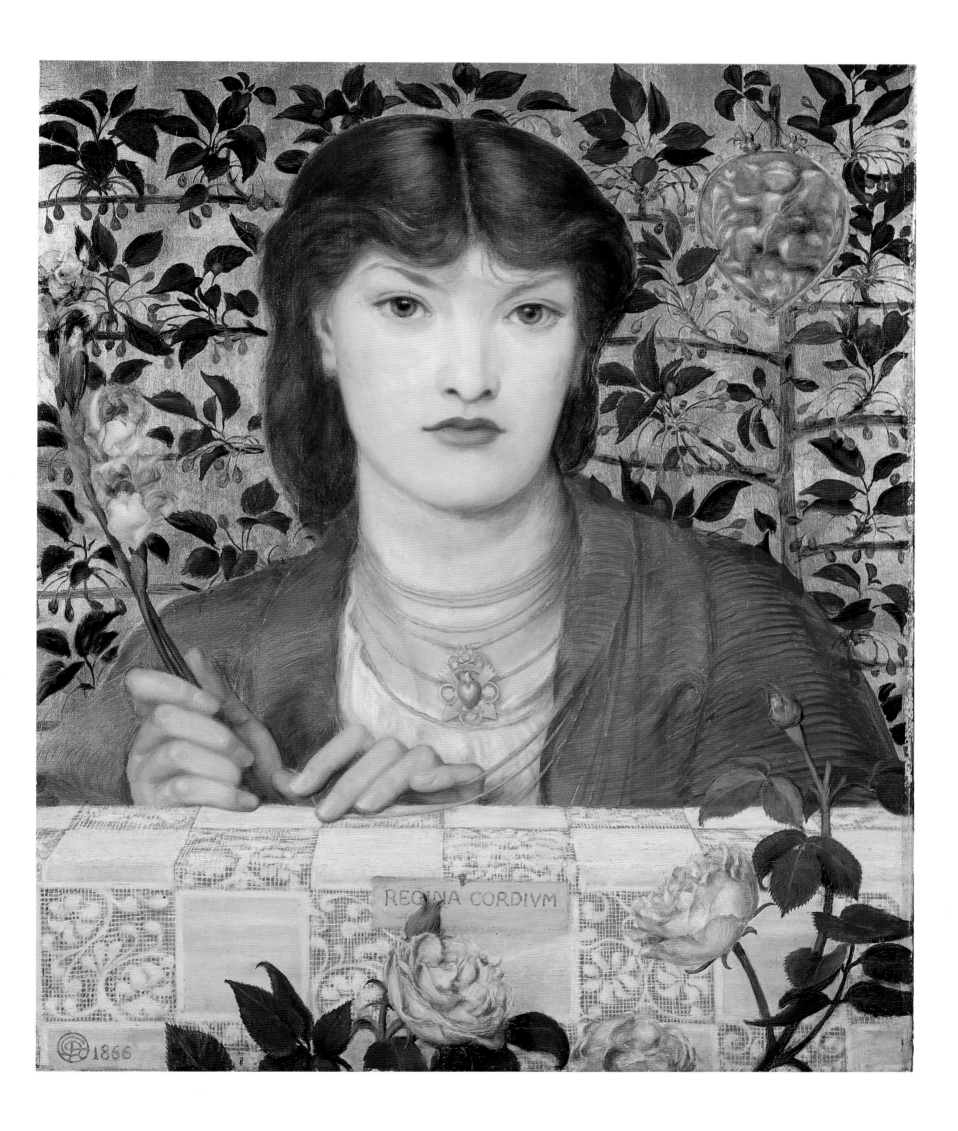

PLATE 21

MONNA VANNA
—— 1866 ——
Oil, 35 x 34 in / 88.9 x 86.4 cm
Tate Gallery, London

Originally entitled *Venus Veneta*, this picture was renamed after its completion to add Italian connotations, Monna Vanna being a character from both Boccaccio and Dante's *Vita Nuova*. Rossetti here portrays the Venetian ideal of feminine beauty, modelled by Alexa Wilding. The opulent sleeve, which may have been inspired by Raphael's *Portrait of Giovanni of Aragon* in the Louvre, was made from the same fabric as that seen in *Monna Rosa* and other paintings Rossetti did during this period. The spiral pearl clasp and red necklace, which echo the circular composition of the picture, were decorative motifs frequently used by Rossetti at this time, the necklace for example also appearing in *Regina Cordium*. The artist initially offered the painting to John Mitchell, who owned *Venus Verticordia*, because he thought 'It would be a splendid match to your more classical Venus'. However, the first owner of *Monna Vanna* was W. Blackmore from Cheshire, who owned *Fazio's Mistress*. It was subsequently purchased by the owner of *The Beloved*, George Rae. In 1873 the painting was retouched at Kelmscott and retitled *Belcolore*, a name that Rossetti felt was more appropriate to the relatively modern look of the picture.

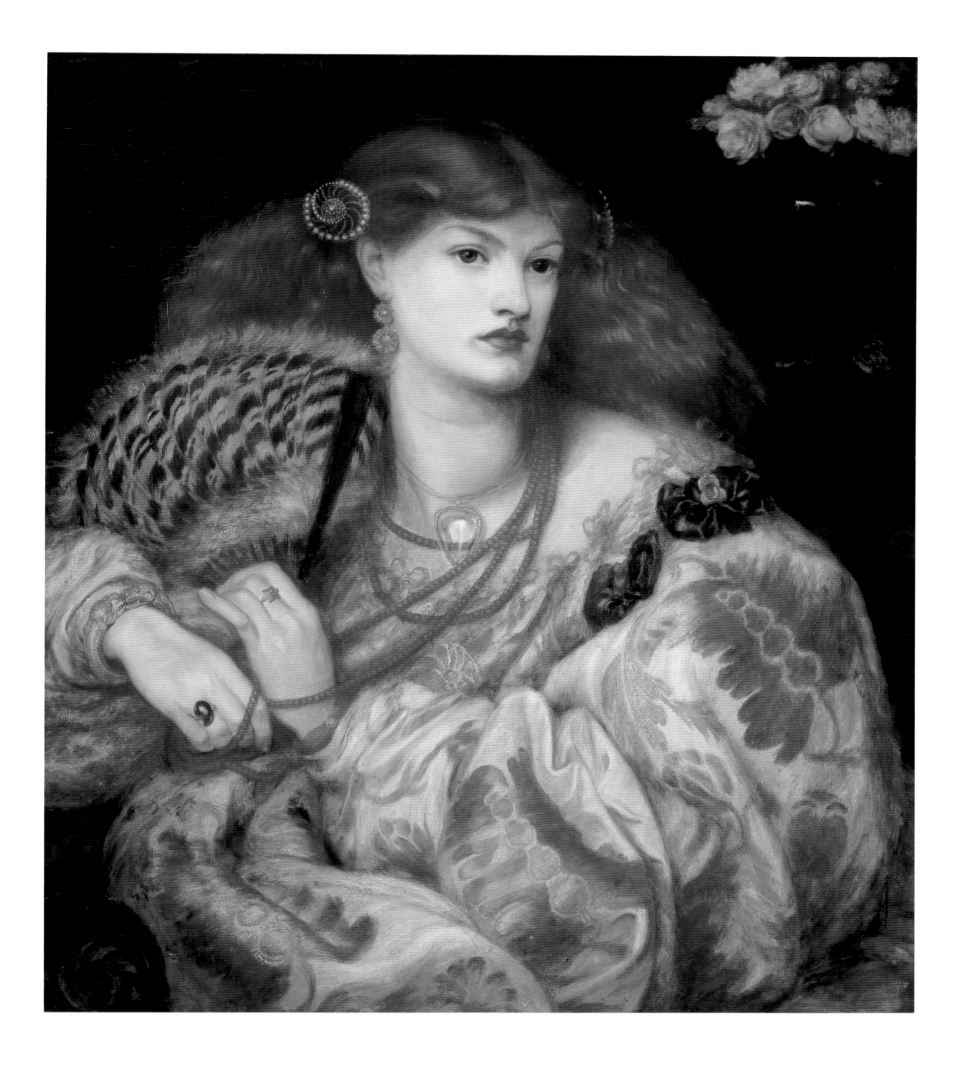

SIBYLLA PALMIFERA
———— 1866–70 ————

Oil, 37 x 32¹/₂ in / 94 x 82.6 cm
Board of Trustees of the National Museums and Galleries on Merseyside
(Lady Lever Art Gallery, Port Sunlight)

Commissioned in 1866 by George Rae, this painting was originally called simply *Palmifera*; adding *Sibylla* was an afterthought. In a letter to his brother William, Rossetti explained that: 'The title Palmifera was adopted to mark the leading place which I intend her to hold among my beauties.' In 1869 Rossetti wrote to the artist James Smetham, asking him to help with the perspective of the background, but the degree of assistance given, if any, is unknown. Leyland requested a replica (a common practice, and one that Rossetti often undertook), but no duplicate of this painting is known. The model here, Alexa Wilding, represents 'the Palm-giver, i.e. the Principle of Beauty', as he described her – but the beauty of the soul in contrast to the beauty of the body in *Lady Lilith*. Rossetti composed this accompanying sonnet:

> Under the arch of Life, where love and death,
> Terror and mystery, guard her shrine, I saw
> Beauty enthroned; and though her gaze struck awe,
> I drew it in as simply as my breath.
> Hers are the eyes which, over and beneath,
> The sky and sea bend on thee,—which can draw,
> By sea or sky or woman, to one law,
> The allotted bondman of her palm and wreath.
>
> This is that Lady Beauty, in whose praise
> Thy voice and hand shake still,—long known to thee
> By flying hair and fluttering hem,—the beat
> Following her daily of thy heart and feet,
> How passionately and irretrievably,
> In what fond flight, how many ways and days!

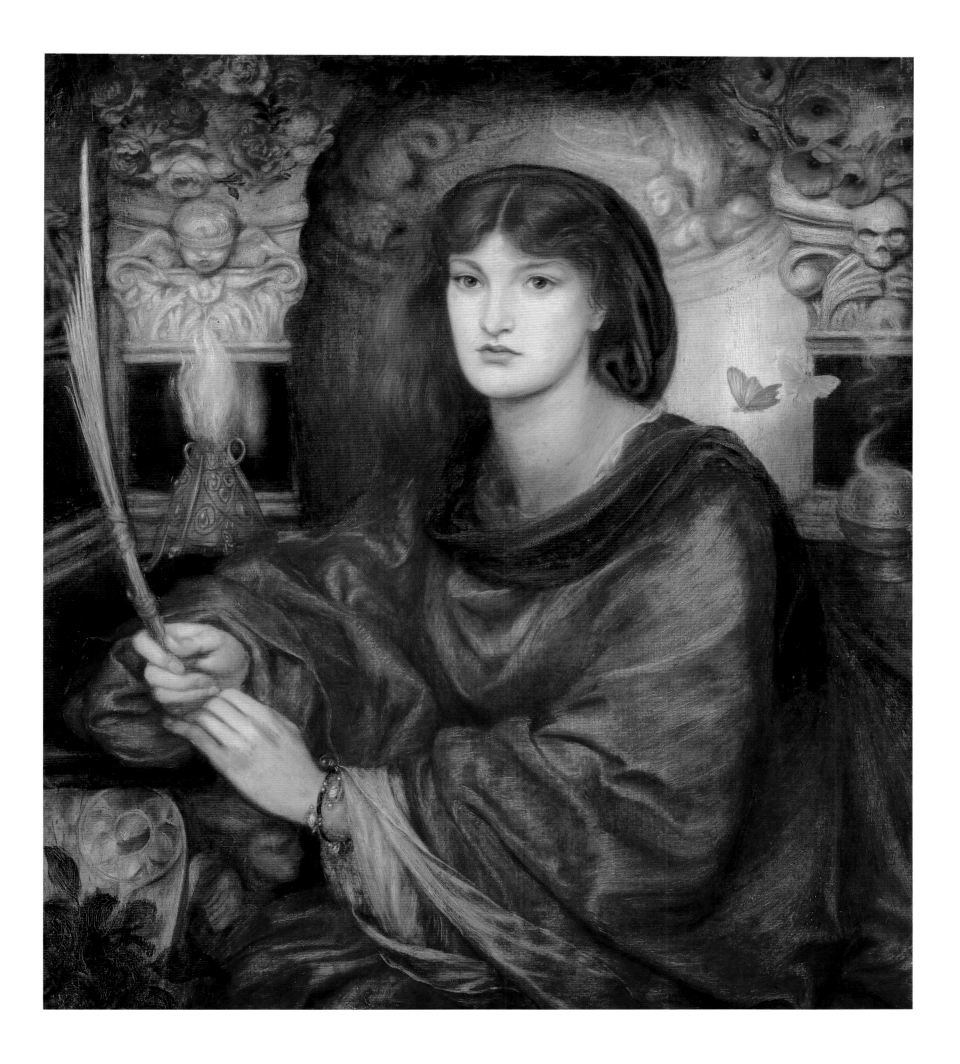

LADY LILITH
——— 1868 ———
Oil, 37$\frac{1}{2}$ x 32 in / 95.3 x 81.3 cm
Delaware Art Museum: Samuel and Mary R. Bancroft Memorial

According to Talmudic legend, Lilith was the beautiful and elegant, yet evil, wife of Adam before Eve. Viraginous women were a popular subject in art and literature of the period, and here Rossetti captures his subject's aloofness. The picture has a cold ambience reminiscent of *Monna Vanna*, her luscious hair used effectively as a symbol of sexual power (a motif that was later taken up by Symbolist and Art Nouveau artists). Rossetti's poem *Lilith* explains the subject:

> Of Adam's first wife, Lilith, it is told
> (The witch he loved before the gift of Eve,)
> That, ere the snake's, her sweet tongue could deceive,
> And her enchanted hair was the first gold.
> And still she sits, young while the earth is old,
> And, subtly of herself contemplative,
> Draws men to watch the bright net she can weave,
> Till heart and body and life are in its hold.
>
> The rose and poppy are her flowers; for where
> Is he not found, O Lilith, whom shed scent
> And soft-shed kisses and soft sleep shall snare?
> Lo! as that youth's eyes burned at thine, so went
> Thy spell through him, and left his straight neck bent,
> And round his heart one strangling golden hair.

Taken from Ruskin's garden, the white roses in the background may seem inappropriate, but they refer to the legend of all the roses in Eden having been white until they blushed at Eve's beauty. The earthy Fanny Cornforth sat for the painting initially, but Leyland, who commissioned it, complained. Rossetti agreed that Fanny's features were too sensual and decided to repaint the face based on the more classically beautiful Alexa Wilding. Not wishing to offend Fanny, he made the amendments in secret at Kelmscott in 1872–73. Rossetti was eager to please Leyland and so changed the painting without charge, but commented: 'I have often said that to be an artist is just the same thing as to be a whore, as far as dependence on the whims and fancies of individuals is concerned.'

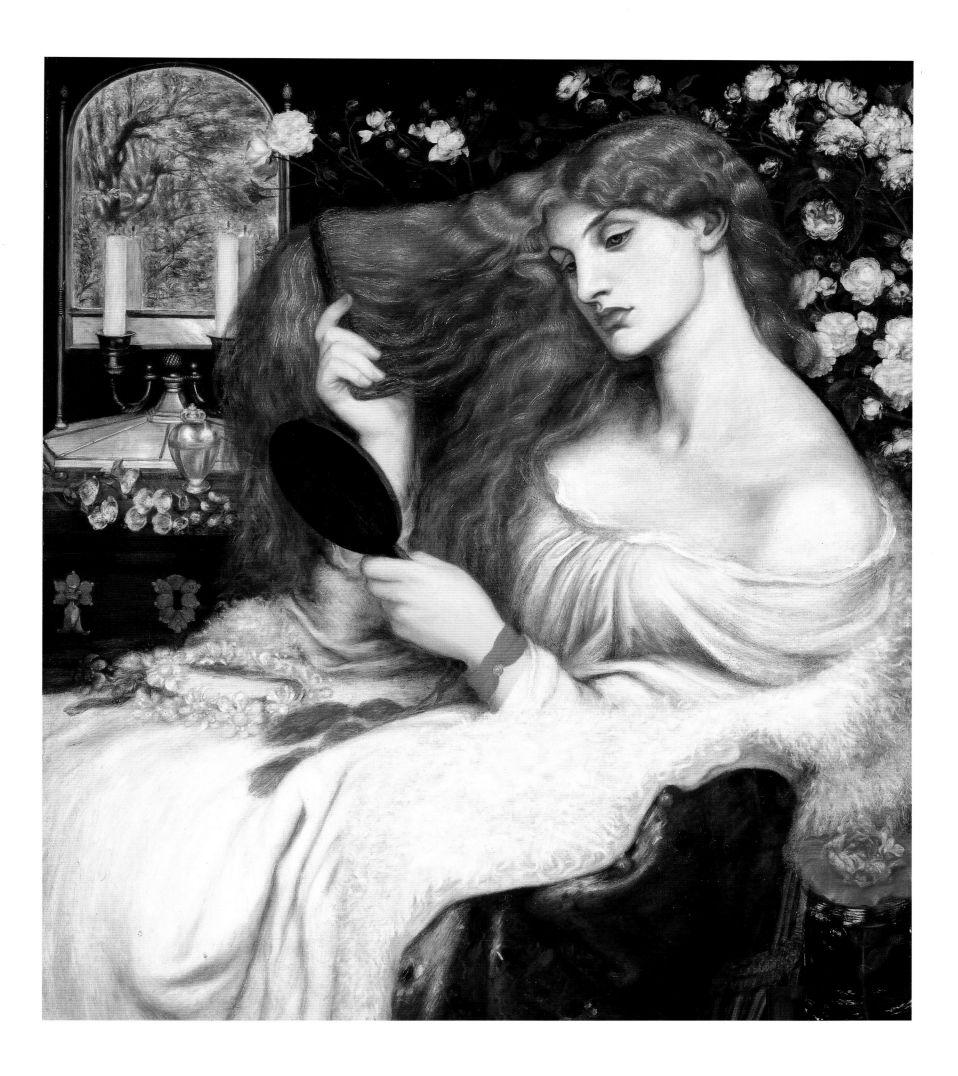

LA PIA DE' TOLOMEI
—————— 1868–80 ——————
Oil, 41¼ x 47½ in / 104.8 x 120.6 cm
Spencer Museum of Art, University of Kansas

Commissioned by Leyland for £800, this painting took its subject from Dante's *Purgatorio*. Rossetti may also have been introduced to the story by a play of the same title by Charles Marenco that ran in London in 1856. La Pia was imprisoned in a fortress in marshy Maremma by her husband and was left to die without receiving absolution. On the frame Rossetti quoted the words her suffering spirit speaks to Dante in the fifth Canto of *Purgatorio*:

> Ah! When on earth thy voice again is heard,
> And thou from the long road hast rested thee
> (After the second spirit said the third),
> Remember me who am La Pia; me
> Siena, me Maremma, made, unmade,
> This in his inmost heart well knoweth he
> With whose fair jewel I was ringed and wed.

Here the languid and melancholic Jane Morris touches her wedding ring. In earlier sketches, for which Alexa Wilding posed, La Pia's head was tilted back, but this configuration was altered to emphasize the hands and wedding ring. In 1868 Swinburne described how 'her pallid splendid face hangs a little forward, wan and white against the mass of dark deep hair… In her eyes is a strange look of wonder and sorrow and fatigue.' Rossetti obtained sketches of the Maremma swamps by Fairfax Murray, and Frederic Shields was asked to supply photographs (an aid that Rossetti often employed) of ivy, representing life in death, growing on a wall. The fig tree symbolizes fruitfulness, the sundial, embellished by a wheel of fortune, refers to life's unpredictable changes. Living up to her name, La Pia has a rosary and prayer book beside her, indicating her piety.

Proud of his model, Rossetti held a dinner party to celebrate the beginning of this overwhelmingly symbolic picture. However, he was still racked with guilt about Lizzie's death and the resulting insomnia gave him severe eye strain, which hindered his progress on the painting.

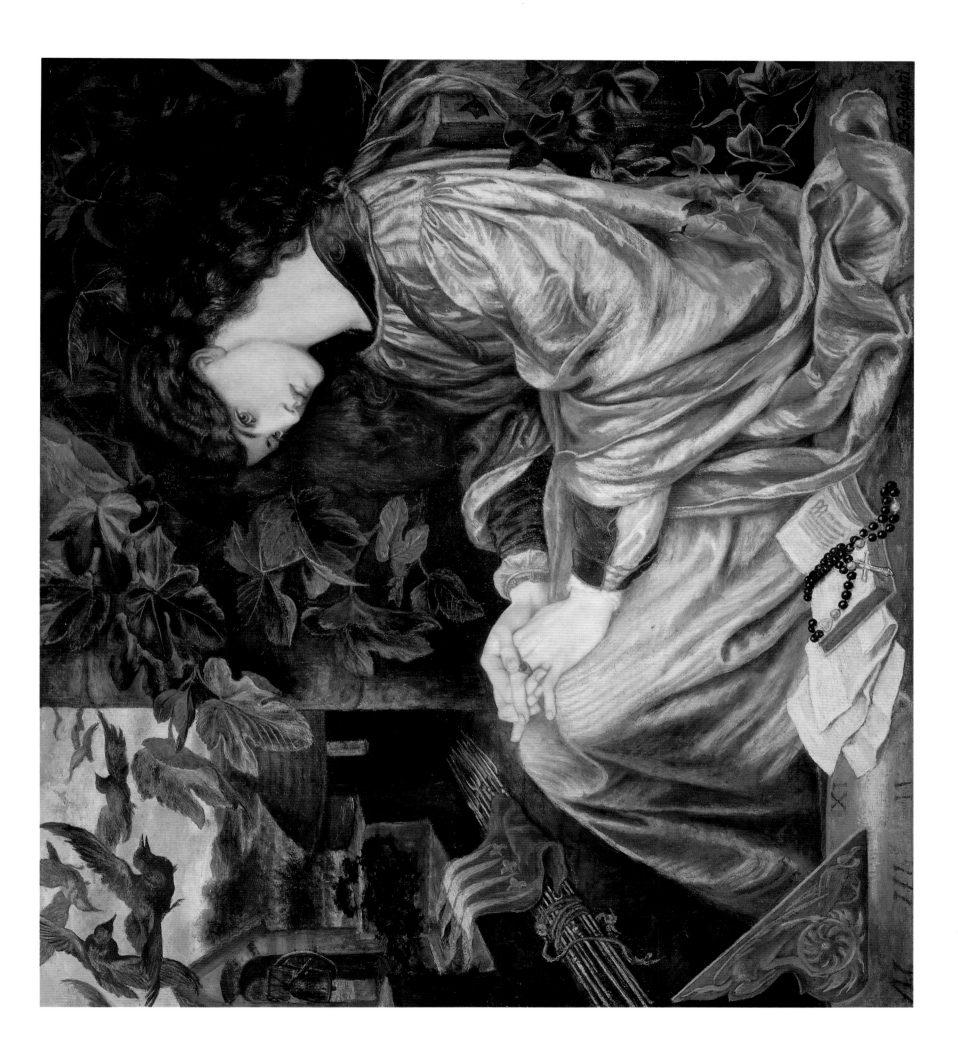

PLATE 25

MARIANA
——— 1868–70 ———
Oil, 43 x 35 in / 109.2 x 88.9 cm
Aberdeen Art Gallery and Museum

His ultimately – almost inevitably – doomed relationship with Jane Morris, and the common knowledge of its intimate nature, dominated the last decade of Rossetti's life, and the strain was reflected in his work. *Mariana*, bought by William Graham for £500, is an unrelievedly melancholic depiction of Jane, yet one that has a rich sensuality. She wears the vivid blue dress seen also in *Portrait of Mrs William Morris*, begun contemporaneously in 1868. The subject is taken from the opening scene of the fourth act of Shakespeare's *Measure for Measure*. Rossetti conceived of Mariana as having been working on a piece of embroidery but being distracted by the boy's song, which is inscribed on the frame:

> Take, O take those lips away,
> That so sweetly were forsworn;
> And those eyes, the break of day,
> Lights that do mislead the morn:
> But my kisses bring again,
> Bring again;
> Seals of love, but seal'd in vain
> Seal'd in vain.

The song of the petulant pageboy, here a portrait of Willie, the buyer William Graham's son, reminds her of her lover Angelo's broken promise of marriage. Rossetti's interest in the subject may also have been inspired by Tennyson's poems on the story.

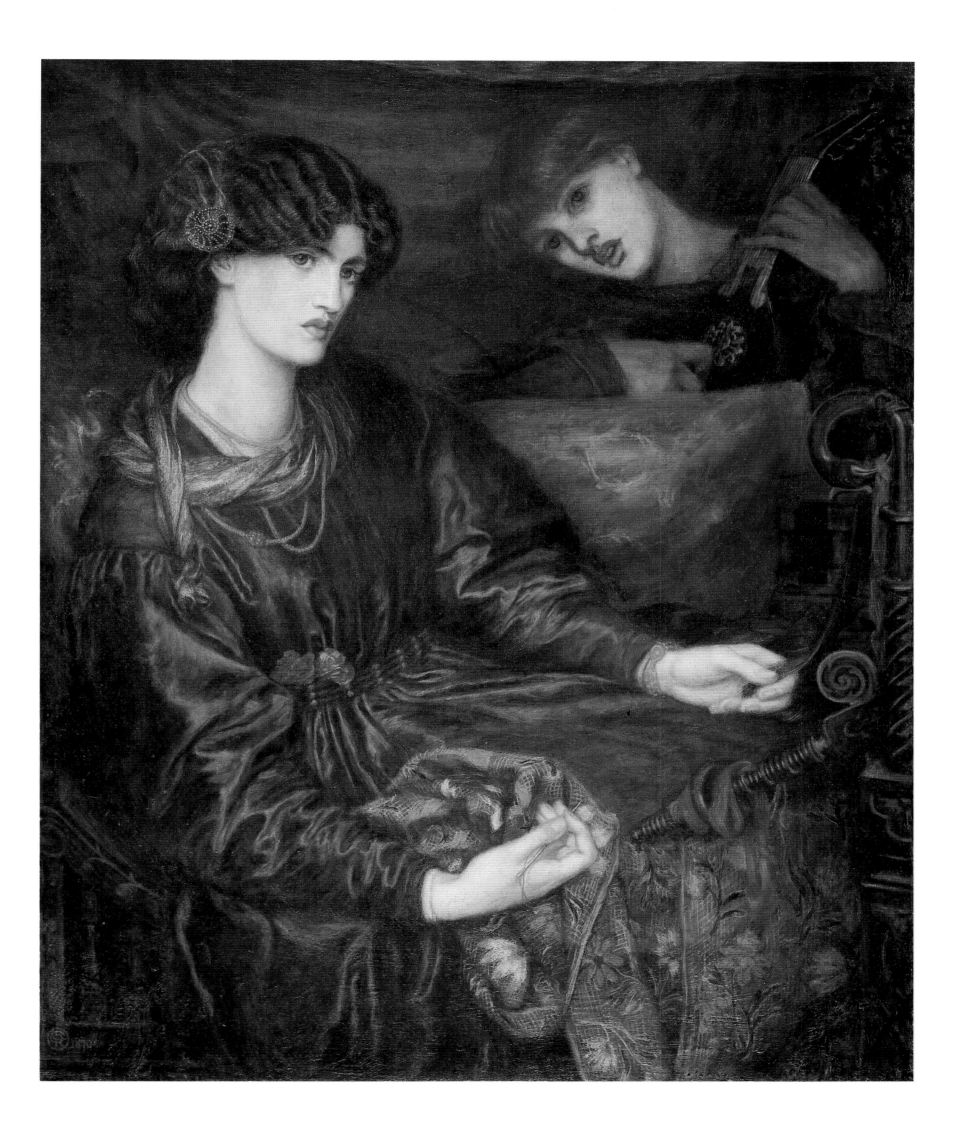

PLATE 26

LA DONNA DELLA FIAMMA
———— 1870 ————
Coloured chalks, 39⅝ x 29⅝ in / 100.7 x 75.3 cm
Manchester City Art Galleries

This is a finished drawing in coloured chalks for a painting that was never executed. This medium was the least problematic for Rossetti, whose eyes were particularly troublesome at the time (Degas similarly turned to pastels when his eyesight began to fail). The study was originally bought by the dealer Leonard Rowe Valpy and then sold to Clarence Edmund Fry (the Fry of Elliot & Fry, one of the leading Society portrait photographers of the nineteenth century). The picture concentrates intensely on Jane, ethereal yet at the same time imposing, whose right hand releases a winged figure of love in flames (possibly inspired by William Blake). On her left wrist is a circular mark. Again our attention is drawn towards the elegant model's hands. The theme of fiery love, also prevalent in Rossetti's poetry at this time, was derived from the passage of Dante's *Vita Nuova* in which Beatrice's capacity to engender love is described:

> Whatever her sweet eyes are turned upon,
> Spirits of love do issue thence in flame.

Like other works from this period, such as *Mariana* and *La Pia de' Tolomei*, the pose here is based upon Rossetti's 1865 series of photographs of Mrs Morris. Her fragile health at the time resulted in languid and subsequently introspective poses.

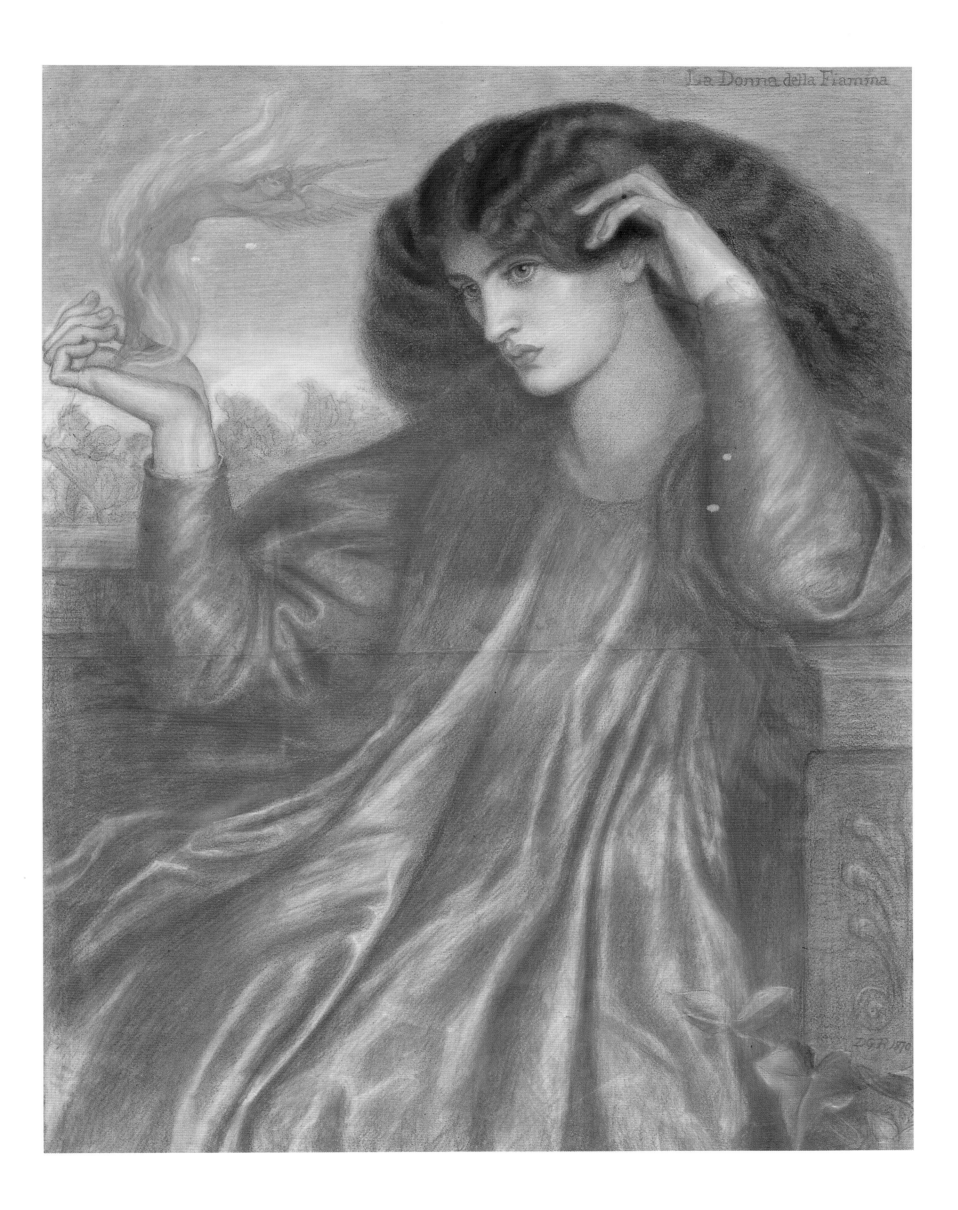

PLATE 27

DANTE'S DREAM AT THE TIME OF THE DEATH OF BEATRICE
———————————— 1871 ————————————

Oil, 83 x 125 in / 210.8 x 317.5 cm
Board of Trustees of the National Museums and Galleries on Merseyside
(Walker Art Gallery, Liverpool)

This was Rossetti's last major subject from Dante connected to the theme of *Beata Beatrix*. It was taken from the passage in the *Vita Nuova* in which Dante dreams of the death of Beatrice and the women who cover her with a white veil. The figure of Love was posed by Johnston Forbes-Robertson, later a famous actor. In 1869 Rossetti wrote to the ailing Jane in Germany to ask her to sit for the piece:

'I also want awfully bad to…do the Beatrice in the big picture…a nice easy sitting. But a thousand times more than any work do I desire your renewed health, dear Janey, and you know how anxiously I await all tidings on the subject.'

This was Rossetti's largest painting, measuring approximately 7 by 10½ feet, and was based on an 1856 watercolour commissioned by Ellen Heaton. This version, commissioned by William Graham in 1869, proved too large for a domestic setting and was therefore exchanged for a smaller version with additional predellas (supplementary pictures). In 1873 Valpy acquired the large painting but he returned it later on his retirement to a small home in Bath. He too bargained for smaller works in exchange but at exorbitant and troublesome terms. Rossetti complained about this in a letter written in September 1878 to Jane: 'I have got into rather a hobble with Valpy – who is a vampire in his requirements – as to the Dante exchange business.' Eventually, with the help of the tireless Thomas Hall Caine, the painting was acquired by the Walker Art Gallery in Liverpool.

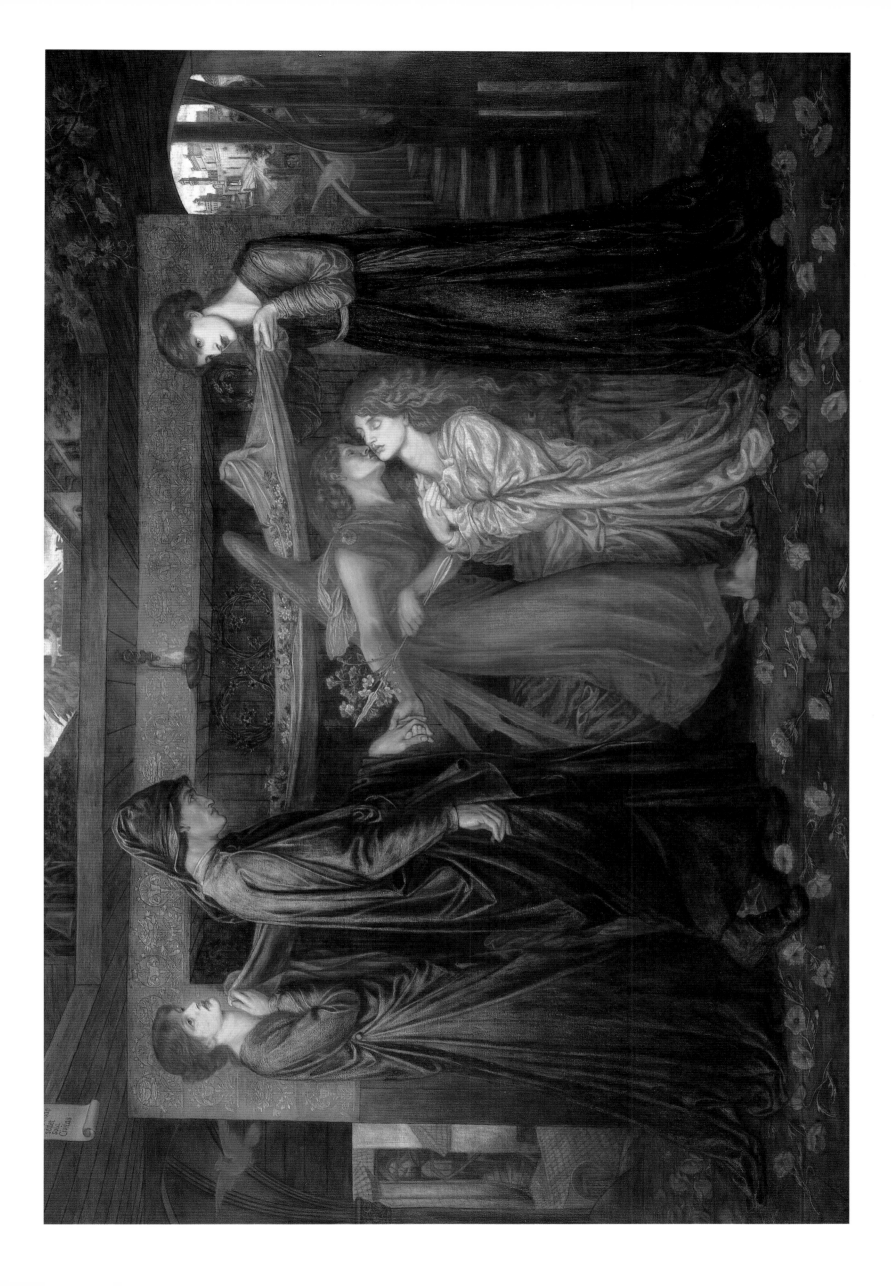

VERONICA VERONESE
—————— 1872 ——————
Oil, 43 x 35 in / 109.2 x 88.9 cm
Delaware Art Museum: Samuel and Mary R. Bancroft Memorial

Veronica Veronese was commissioned by Leyland and bought in 1872 prior to its completion; Rossetti later painted *A Sea Spell* as a companion piece. Modelled by Alexa Wilding wearing a green velvet dress belonging to Jane Morris, the painting depicts a woman as an icon of creativity. Here Rossetti used unusual flower symbolism. The daffodil is a member of the narcissus family and thus alludes to the narcissistic temperament of the creative mind. The primrose, significant to February, tells us in which month the painting was completed. The literary source of the painting, inscribed in French on the frame, was, according to William Rossetti, written by Swinburne and can be translated as:

'Suddenly leaning forward, the Lady Veronica rapidly wrote the first notes on the virgin page. Then she took the bow of the violin to make her dream reality; but before commencing to play the instrument suspended from her hand, she paused for a few moments, listening to the inspiring bird, while her left hand strayed over the strings searching for the supreme melody, still elusive. It was the marriage of the voices of nature and of the soul – the dawn of a mystic creation.'

Rossetti explained to Leyland:

'The girl is in a sort of a passionate reverie, and is drawing her hand listlessly along the strings of a violin which hangs against the wall, while she holds the bow with the other hands, as if arrested by the thought of the moment, when she was about to play. In colour I shall make the picture a study of varied greens.'

Rossetti was probably inspired by the book *Iconologia*, written by his friend the artist Filippo Pistrucci, in which Love, Art and Eternity are all female figures in classical green gowns.

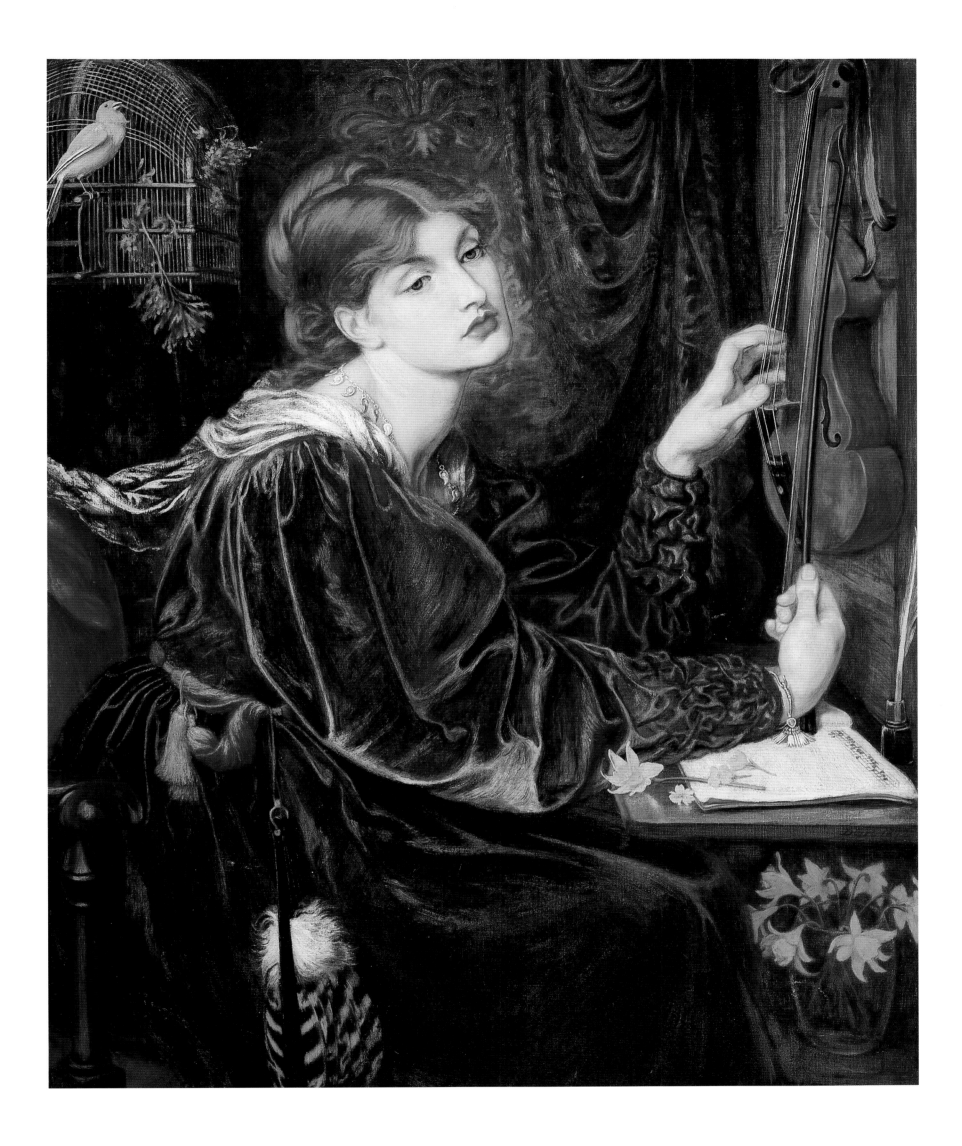

PLATE 29

THE BOWER MEADOW
—— 1871–72 ——
Oil, 33½ x 26½ in / 85.1 x 67.3 cm
Manchester City Art Galleries

The landscape in the background was originally painted 'from nature' alongside Holman Hunt in Knole Park, Kent in November 1850 for a *Dante and Beatrice in Paradise*. At that time Rossetti wrote to Stephens:

'I have got some trees in the picture which I must set about immediately on completing my design, for which purpose I shall have to pitch my tent at Sevenoaks for some days...the subject which relates to Dante interests me tremendously and requires some consideration...I understand that of course there is a stunning country to paint from there.'

In the execution of the landscape, Rossetti's abandonment of Pre-Raphaelite Brotherhood principles was profoundly apparent. This was expounded in a letter to his friend Jack Tupper:

'The fact is, between you and me, that the leaves on the trees I have to paint here appear red, yellow etc. to my eyes; and...it seems rather annoying that I cannot do them so: my subject shrieking aloud for Spring.'

Rossetti later superimposed four figures on to the landscape: two languid dancers and two women in the foreground playing musical instruments, modelled by Maria Spartali on the left and Alexa Wilding on the right. The symmetry of the figures and their colouring recall early Italian paintings of musical angels.

The Bower Meadow was sold to Pilgeram and Lefevre in June 1872 for £735. Rossetti had been suffering from a sense of persecution, and the high price he obtained for this work somehow further fuelled his paranoid delusions. It was shortly sold on to Walter Dunlop who later regretted it, having exchanged *Le Roman de la Rose* and *Ophelia* for part of the price.

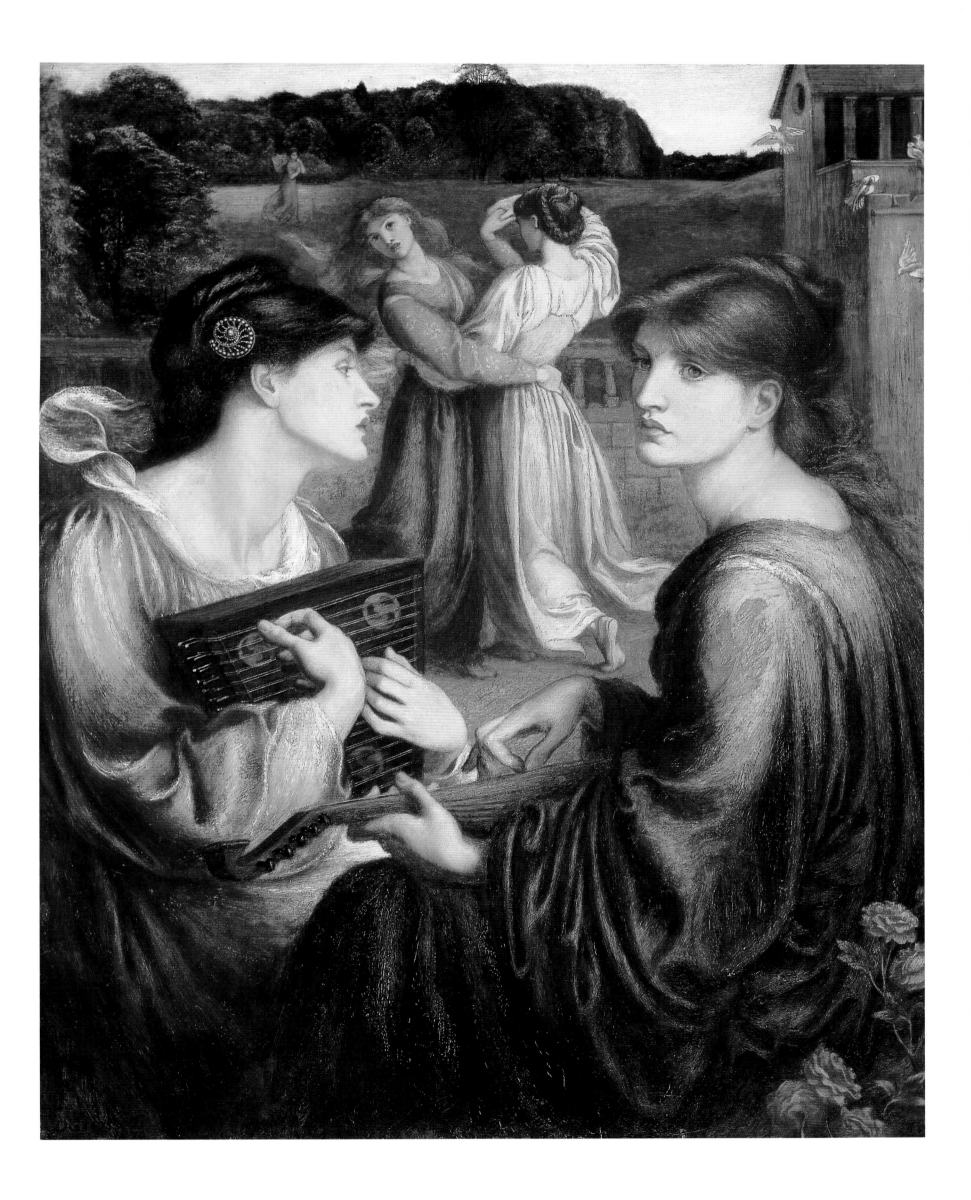

Beata Beatrix
——— 1872 ———
Oil, 34¹/₂ x 27¹/₄ in / 87.5 x 69.3 cm (predella 11⁵/₈ x 27¹/₄ in / 26.5 x 69.2 cm)
Art Institute of Chicago, Charles L. Hutchinson Collection

This is a replica of the *Beata Beatrix* that Rossetti painted as a memorial to Lizzie Siddal, who died of a laudanum overdose on 11 February 1862. Begun many years before, the original visionary portrait was taken up again in 1864 and completed in 1870. The iconography in this painting is dense, fusing the artist's personal experience with legendary and literary sources. During the initial stages of the painting, Rossetti explained the imagery:

'The picture illustrates the *Vita Nuova*, embodying symbolically the death of Beatrice as treated in that work. The picture is not intended at all to represent death, but to render it under the semblance of a trance, in which Beatrice, seated at a balcony overlooking the city, is suddenly rapt from Earth to Heaven. You will remember how Dante dwells on the desolation of the city in connection with the incident of her death, and for this reason I have introduced it as my background, and made the figures of Dante and Love passing through the street and gazing ominously on one another, conscious of the event; while the bird, a messenger of death, drops the poppy between the hands of Beatrice. She, through her shut lids, is conscious of a new world, as expressed in the last words of the *Vita Nuova* – "That blessed Beatrice who now gazeth continually on His countenance, who is through all ages blessed."'

Intensely emotional for a secular painting, this immortalization of a woman as almost a spiritual icon shows the development of a trend for half-length female figures in an ecstatic trance. This was anticipated in Rossetti's 1857 wood engraving *Saint Cecilia* in its configuration, as well as in motifs such as the dove and the sundial. The pose was first apparent in the 1851 sketches for his erotic watercolour *The Return of Tibullus to Delia* (1853; Private collection). It is not known whether Lizzie naturally assumed the pose or Rossetti decided to position her in this way. In 1871 William Graham wrote to Rossetti begging for a replica:

'I know the labour of repeating, apart from the delight of invention and the surprise of your discovery, is especially hard to your temperament...the Beatrice, from the first day I saw it, has appealed to my feeling altogether above and beyond any picture I ever saw, and the love for it has only deepened.'

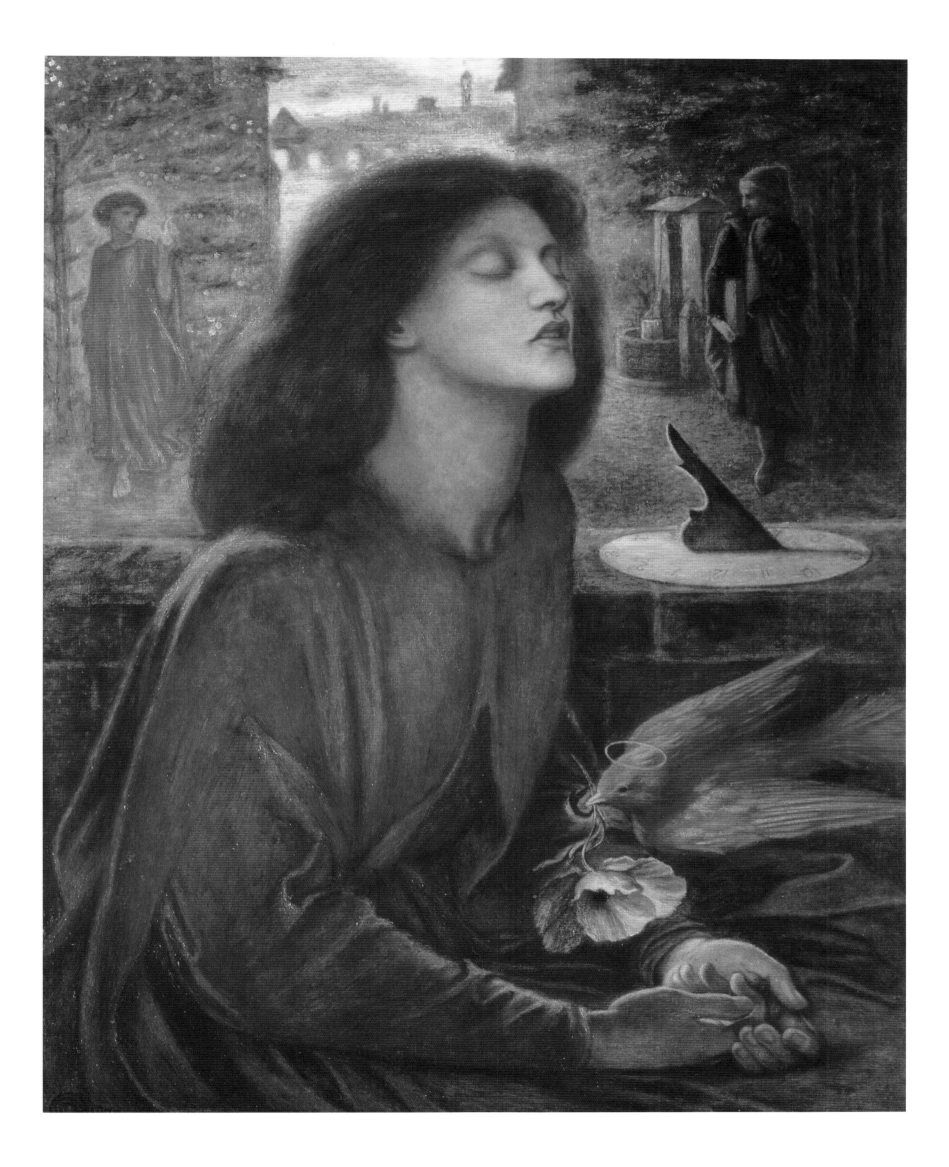

LA GHIRLANDATA
—— 1873 ——

Oil, 45½ x 34½ in / 115.6 x 87.6 cm
Guildhall Art Gallery, Corporation of London

This is one of a group of works executed between 1871 and 1874 depicting musical women, some bought by Leyland whose musical interests probably inspired the pictures. This particular painting, however, was bought by William Graham for £840 as Leyland preferred single-figure compositions. *La Ghirlandata* is an aesthetic study of Alexa Wilding in a forest setting with May Morris (daughter of Jane and William) as the angels. Rossetti described the painting as: 'The greenest picture in the world…the principal figure being draped in green and completely surrounded with glowing green foliage.' The harp has blue wings, symbolizing the flight of time. The garland that gives the painting its title is composed of roses and honeysuckle, which refer to sexual attraction – as they had in *Venus Verticordia*, according to Ruskin. The painting was done at Kelmscott in the summer of 1873. In a letter Rossetti told his assistant Henry Treffry Dunn:

'I wrote to Graham yesterday abt. the big picture. The one I am doing for him now is not *Blessed Damozel* but that figure painting on the queer old harp which I drew from Miss W. when you were here. The 2 heads of little May are at the top of the picture. It ought to put Graham in good humour & I am glad he is to have it as he is the only buyer I have who is worth a damn.'

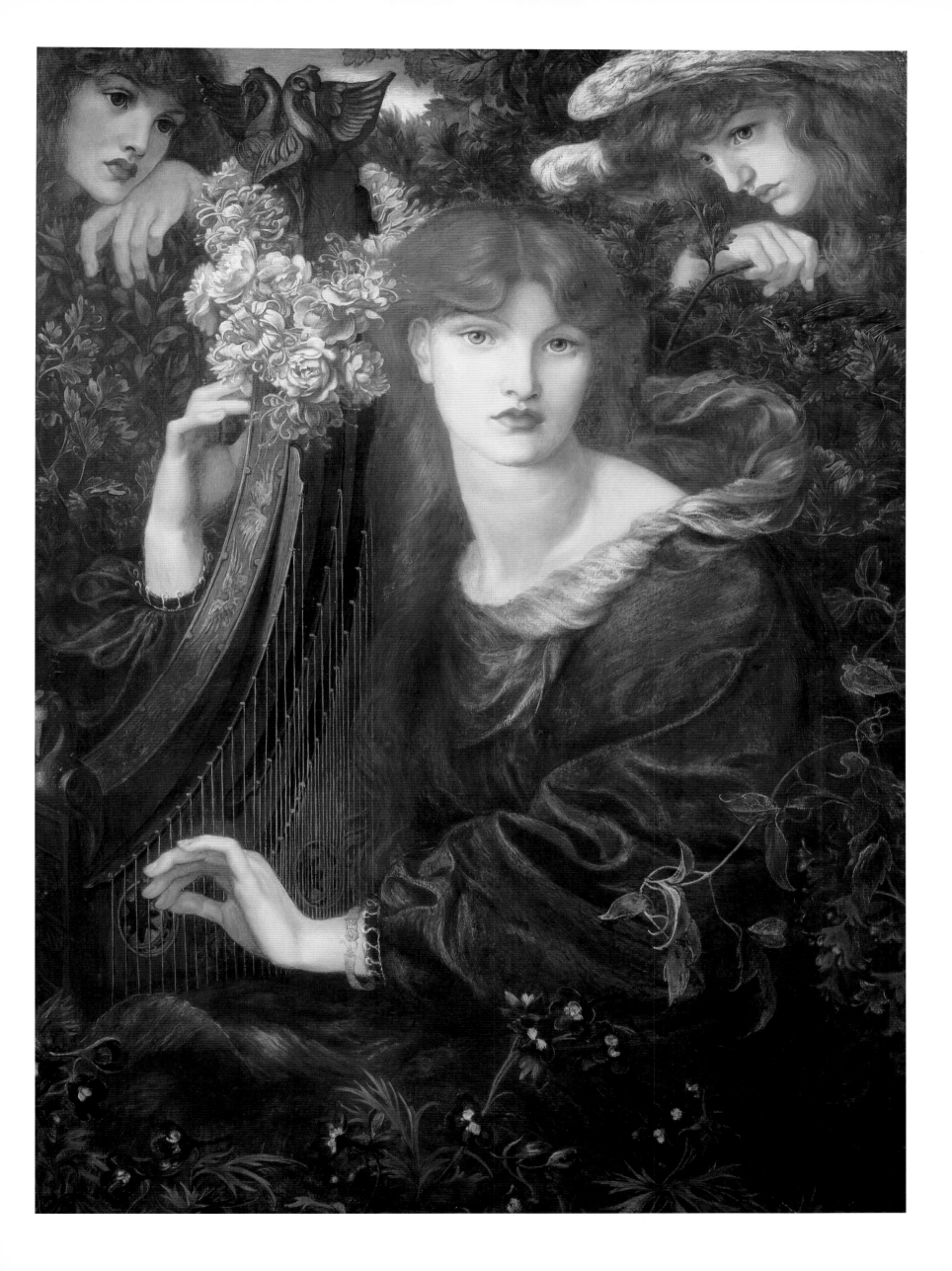

PROSERPINE
—— 1874 ——
Oil, 49 ¾ x 24 in / 126.4 x 61 cm
Tate Gallery, London

This is one of many versions of a painting that Rossetti regarded as among his favourites – although its history was such a catalogue of disasters that it is surprising he did not come to detest it. Originally a commission from Howell and Parsons for £550, it had to be done on a total of eight canvases. Of these, the first two were destroyed by the artist himself, and the third was cut down to become *Blanziflore*. Howell and Parsons took the fourth version in May 1873, but it remained unsold and was returned to Rossetti in February 1874. The fifth version, which was completed in the autumn of 1873, and promised to Leyland, had suffered from problems with the lining and had to be relined. It was apparently lost after departing from Paddington Station, on its return from London to Kelmscott, where Rossetti was working, never to be seen again. Its replacement, the sixth version, was found to have been damaged in transit on its arrival at Leyland's home in Liverpool, was restored by the artist and was eventually owned by the misogynist painter L. S. Lowry. Leyland finally received version seven – which is reproduced here. A later, eighth, replica was completed a few days before Rossetti's death.

Although the figure was originally intended to be Eve with the apple, Jane Morris here portrays Proserpine, Empress of Hades, who was confined there with her husband for most of the year because she had tasted one of the fruits of the Underworld, a pomegranate. Rossetti loved this legend, feeling that its theme – a woman granted only occasional periods of freedom from her husband – was analogous to his relationship with his model. He wrote a sonnet about it in Italian, inscribed on the spray of ivy, 'a symbol of clinging memory':

> (Afar away the light that brings cold cheer)
> Unto this wall – one instant and no more
> Admitted at my distant palace-door.
> Afar the flowers of Enna, from this drear
> Dire fruit, which, tasted once, must thrall me here.
> Afar those skies from this Tartarean grey
> That chills me: and afar, how far away,
> The nights that shall be from the days that were.
>
> Afar from mine own self I seem, and wing
> Strange ways in thought, and listen for a sign:
> And still some heart unto some soul doth pine,
> (Whose sounds mine inner sense is fain to bring,
> Continually together murmuring,) –
> 'Woe's me for thee, unhappy Proserpine!'

Rossetti may also have been inspired by Swinburne's *Hymn to Proserpina* and *Garden of Proserpine*, published in 1866, and also by Aubrey De Vere's poem on Proserpine, mentioned by Rossetti in a letter to Allingham in March 1856. The elongated, thin composition of *Proserpine* may have been influenced by Botticelli's *Portrait of Smerelda Bandinelli*, which Rossetti had bought in 1867.

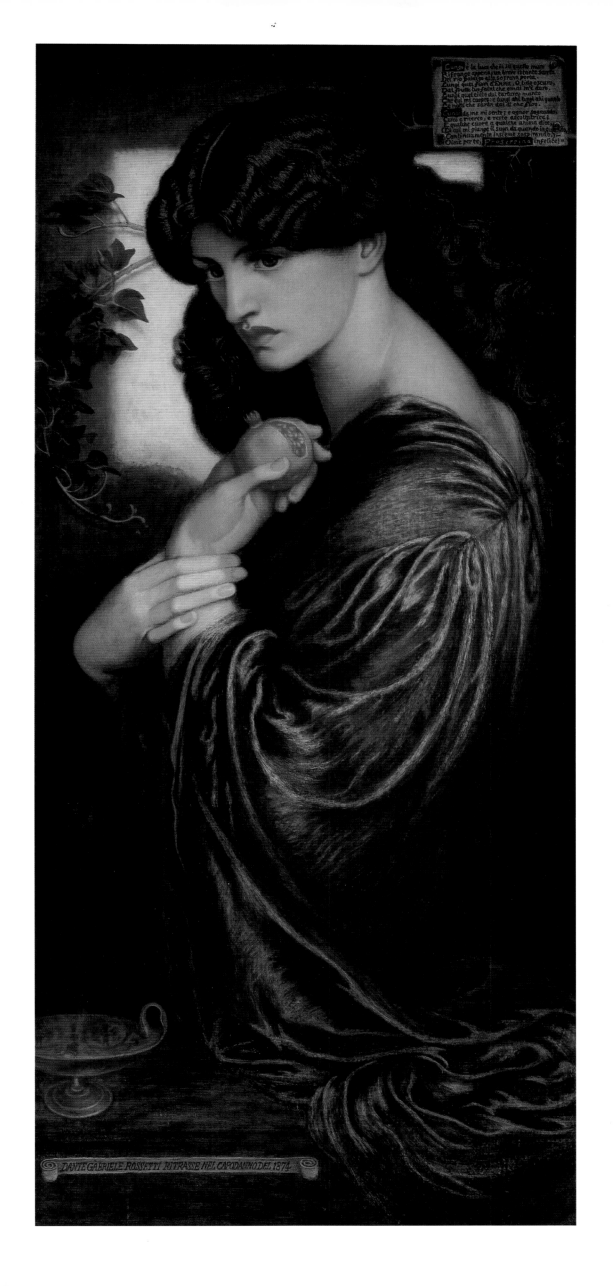

PLATE 33

SANCTA LILIAS
—— 1874 ——
Oil, 19 x 18 in / 48.3 x 45.7 cm
Tate Gallery, London

Initially begun as a larger piece for *The Blessed Damozel*, the painting was cut down to a smaller single-head composition, Alexa Wilding posing for the central figure on the gold background. The drapery of her gold dress is incomplete. In around 1873 Rossetti wrote the following instructions to his assistant Dunn:

'What I want done is that you should get Ford and Dickinson's gilder down to Chelsea and make him gild under your directions the parts where the red ground of the canvas is left, both dress and background. This would require nicety around the edges, and where these seem dubious I will mark them with a white chalk line. When gilded, I will get you to re-pack it as it came and return it to me at once to paint on.'

The picture was originally offered to and accepted by Charles Howell (Rossetti's agent and friend), but was somehow given to the Honourable William and Mrs Cowper-Temple by Rossetti as a memento of his visit to Broadlands in Sussex in August 1876.

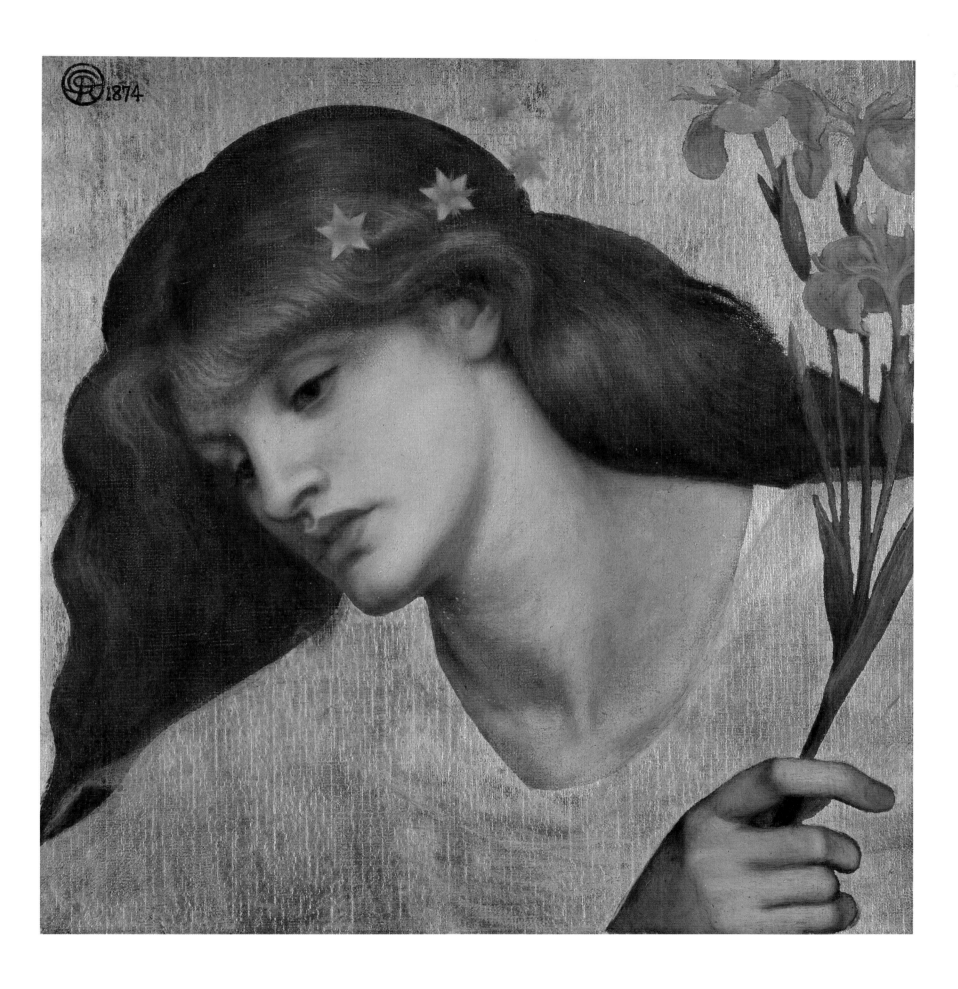

LA BELLA MANO
—————— 1875 ——————
Oil, 62 x 46 in / 157.5 x 116.8 cm
Delaware Art Museum: Samuel and Mary R. Bancroft Memorial

Painted at Cheyne Walk, this picture was commissioned by Murray Marks in February 1875 for £1,050 and bought by his publisher F. S. Ellis. The title refers to a series of Petrarchian sonnets of the same name by Giusto de' Conti, although of course Rossetti wrote his own sonnet on the subject:

> O lovely hand, that thy sweet self dost lave
> In that thy pure and proper element,
> Whence erst the Lady of Love's high advènt
> Was born, and endless fires sprang from the wave:—
> Even as her Loves to her their offerings gave,
> For thee the jewelled gifts they bear; while each
> Looks to those lips, of music-measured speech
> The fount, and of more bliss than man may crave.
>
> In royal wise ring-girt and bracelet-spann'd,
> A flower of Venus' own virginity,
> Go shine among thy sisterly sweet band;
> In maiden-minded converse delicately
> Evermore white and soft; until thou be,
> O hand! heart-handsel'd in a lover's hand.

Alexa Wilding sat for the main figure and May Morris again for the angel. The scallop-shaped basin is a symbol of purity, as is the washing of the hands, which here is not a reference to the end of an affair as it had been in the earlier *Lucrezia Borgia*. The iris and the lemon tree are symbols of the Virgin. Rossetti borrowed many of the objects in the picture from Marks, including a blue jar that was later painted out. The toilet castor also belonged to Marks; actually silver, it was gilded at Rossetti's request without the owner's permission and much to his annoyance. Rossetti also appropriated the needlework table cover that he found in Marks's home when visiting his wife. In trying to obtain the exact shade of flowers that Rossetti insisted upon, Marks spent much time and money in the Covent Garden flower market.

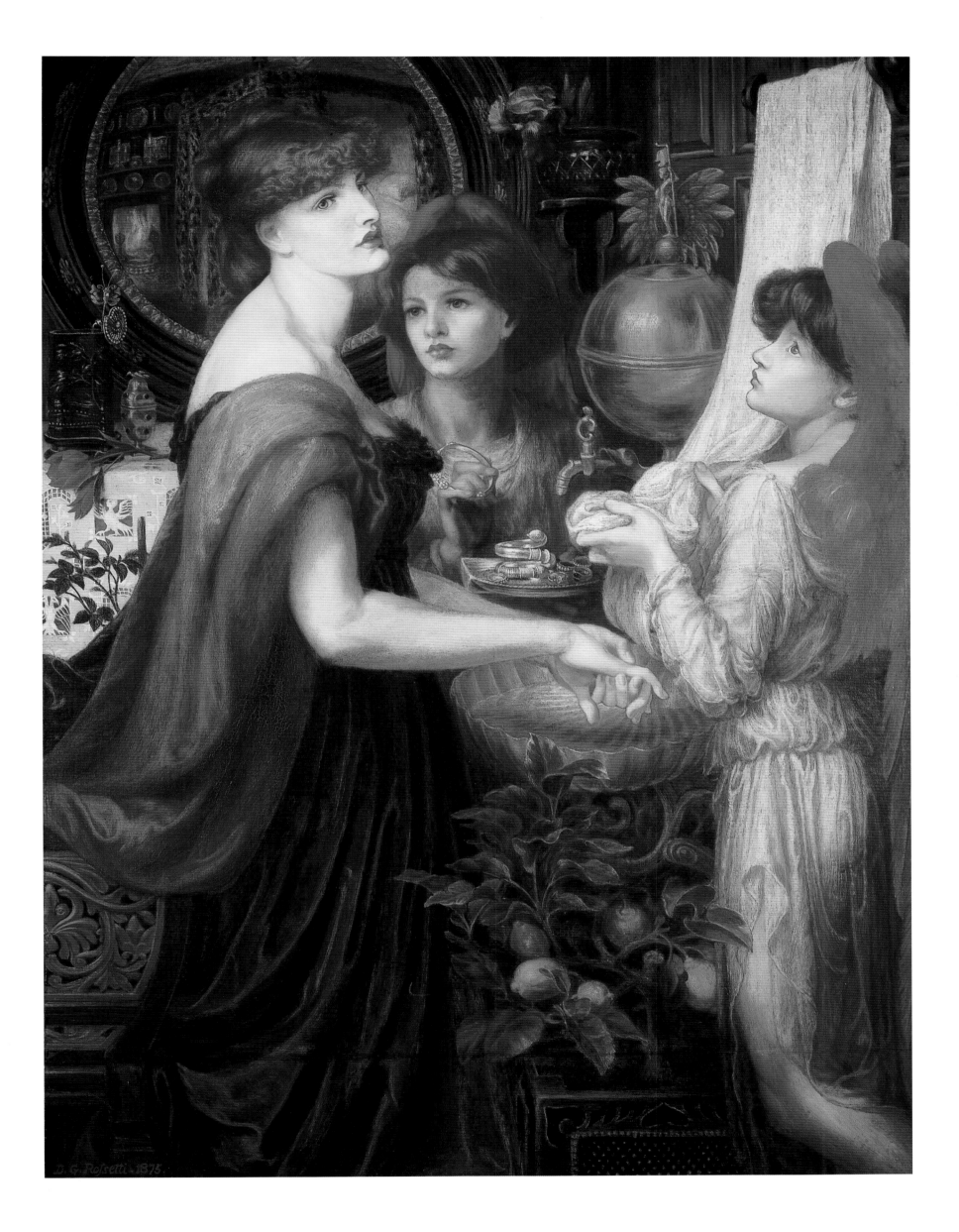

ASTARTE SYRIACA
—————— 1875–77 ——————
Oil, 72 x 42 in / 183 x 106.7 cm
Manchester City Art Galleries

Commissioned in 1875 by Clarence Edmund Fry for £2,100 (the most lucrative commission Rossetti ever received), *Astarte Syriaca* was painted mostly at Aldwick Lodge in Bognor in 1875–76. This, Rossetti's most powerful and devotional tribute to Jane Morris – just as *Beata Beatrix* had been to Lizzie Siddal – was developed from a portrait of her that he had started earlier, entitled *Mnemosyne* (1881, Delaware Art Museum: Samuel and Mary R. Bancroft Memorial). Astarte was the Syrian Aphrodite and here, more so than Venus, she is a potent embodiment simultaneously of all Rossetti's obsessions – legend, religion, art and love – explained in the sonnet he wrote to accompany it:

> Mystery: lo! betwixt the sun and moon
> Astarte of the Syrians: Venus Queen
> Ere Aphrodite was. In silver sheen
> Her twofold girdle clasps the infinite boon
> Of bliss whereof the heaven and earth commune:
> And from her neck's inclining flower-stem lean
> Love-freighted lips and absolute eyes that wean
> The pulse of hearts to the spheres' dominant tune.
>
> Torch-bearing, her sweet ministers compel
> All thrones of light beyond the sky and sea
> The witnesses of Beauty's face to be:
> That face, of Love's all-penetrative spell
> Amulet, talisman, and oracle,—
> Betwixt the sun and moon a mystery.

Venus Astarte has two torch-bearing attendants in this claustrophobic Mannerist composition with surreal lighting in which the *femme fatale* has become immortalized into a pagan love goddess. The roses and pomegranates in the girdle are symbols respectively of the Passion and Resurrection. Astarte's gesture was influenced by the Medici Venus, which was particularly revered and much copied at the time. Rossetti's glazing technique, which gives this painting its luminosity, was perhaps inspired by Titian. In February 1877 he wrote to Theodore Watts-Dunton: 'I have been glazing it and it is much enriched.'

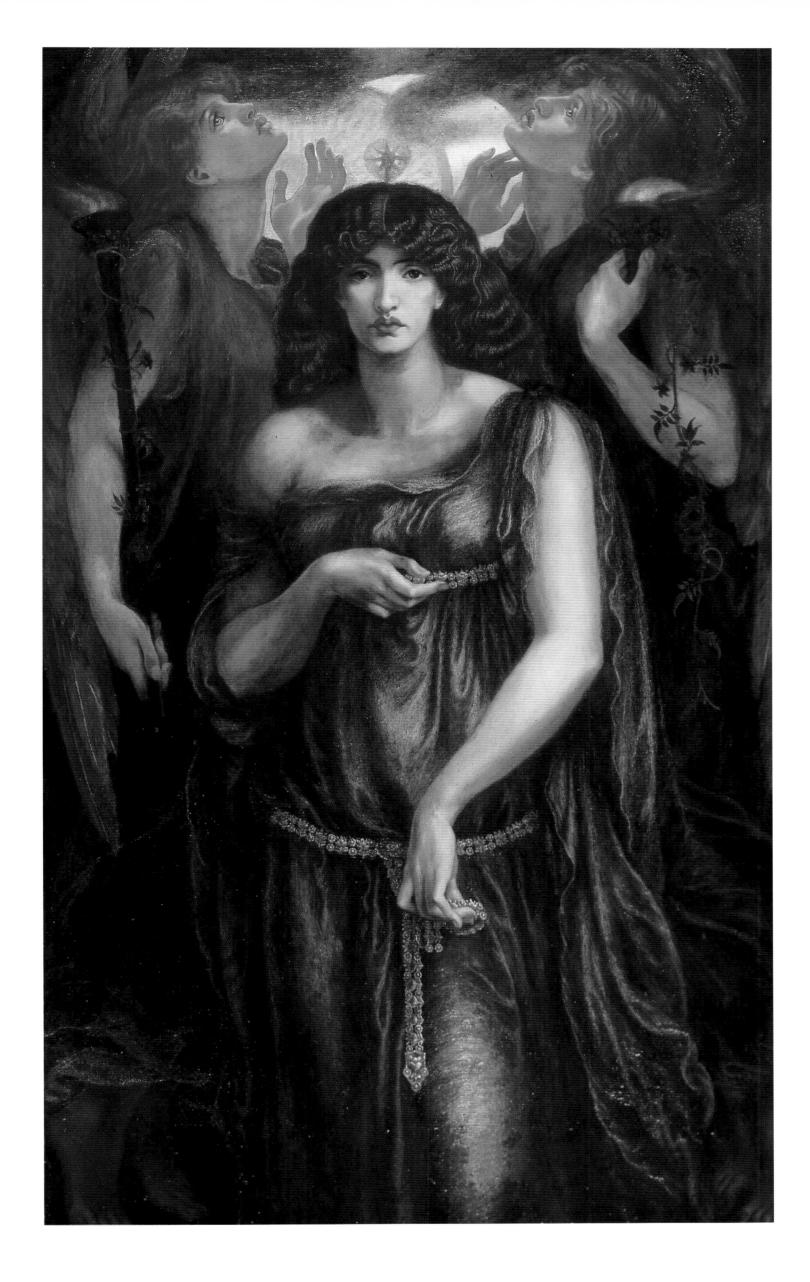

PLATE 36

THE BLESSED DAMOZEL
1875–78
Oil, 68¹/₂ x 37 in / 174 x 94 cm (including predella)
Harvard University Art Museums, Fogg Art Museum,
Bequest of Grenville L. Winthrop

Commissioned in 1871 by William Graham, *The Blessed Damozel* is an illustration for an earlier poem of the same title that had appeared in *The Germ*. It was Rossetti's only painting based on one of his poems (normally the painting came first). The first two verses describe how:

> The blessed damozel leaned out
> From the gold bar of Heaven;
> Her eyes were deeper than the depth
> Of waters stilled at even;
> She had three lilies in her hand,
> And the stars in her hair were seven.
>
> Her robe, ungirt from clasp to hem,
> No wrought flowers did adorn,
> But a white rose of Mary's gift,
> For a service meetly worn;
> Her hair that lay along her back
> Was yellow like ripe corn.

Part of the painting was done during a stay at Broadlands in Sussex with William Cowper-Temple in the summer of 1876, when Rossetti had escaped a heatwave in London. The damozel looks towards earth from heaven, surrounded by angels and lovers, the female lovers resembling Jane Morris. The rhythmic form of the lovers may derive from Botticelli, particularly his *Mystic Nativity* of 1500, which Rossetti had seen in Leeds in 1868. Botticelli's painting depicts pairs of embracing humans and angels in the foreground below a circular dance of angels in heaven. In an inversion of Rossetti's usual deification of living women, here is a truly corporeal heavenly woman, modelled by Alexa Wilding (with his housemaid Mary as the angels). In 1879, at Graham's request, Rossetti added a predella showing the damozel's lover lying under a tree, looking up towards his departed partner.

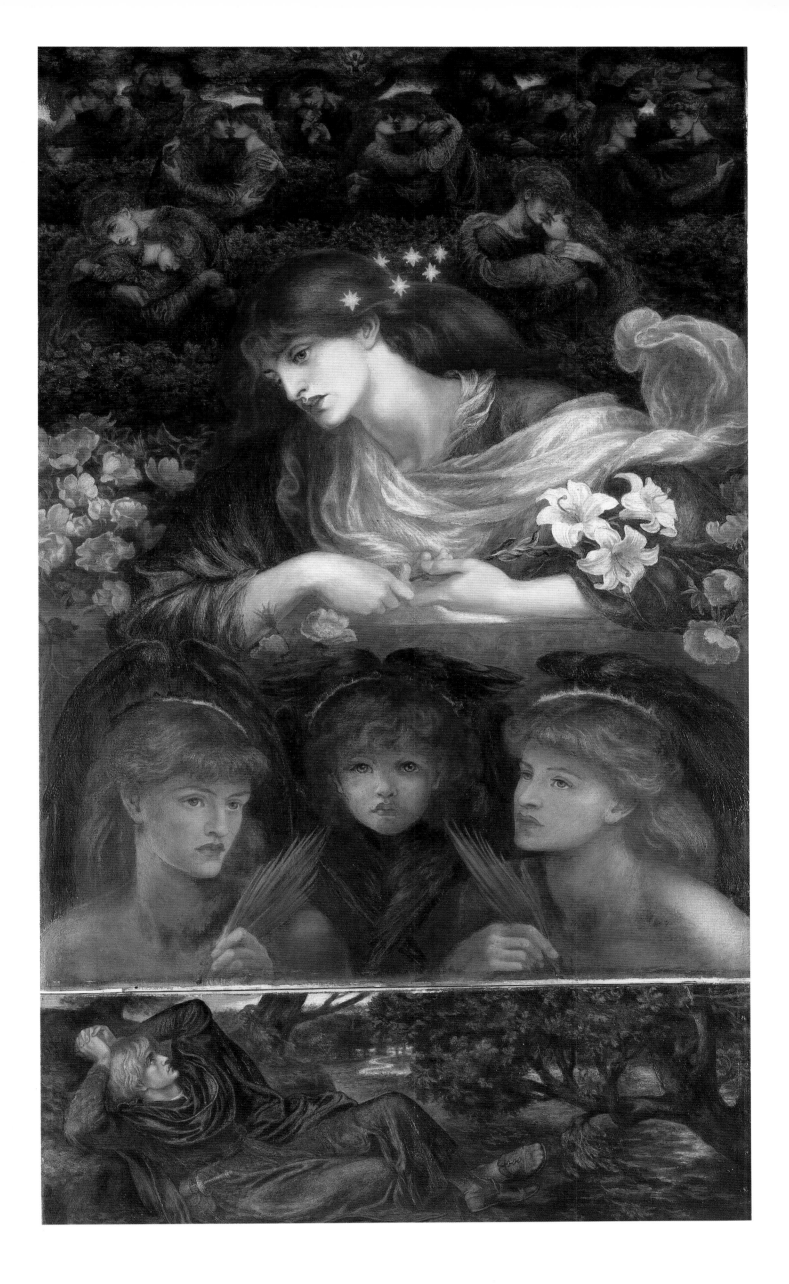

A SEA SPELL
———— 1877 ————

Oil, 42 × 35 in / 106.7 × 88.9 cm
Harvard University Art Museums, Fogg Art Museum,
Bequest of Grenville L. Winthrop

Begun in early 1875, *A Sea Spell* was originally intended to illustrate
the lines from Coleridge's *Kubla Khan*:

> A damsel with a dulcimer
> In a vision once I saw.

Modelled by Alexa Wilding, it was completed in 1877, and offered
to Leyland as a companion picture for *Veronica Veronese*. Rossetti later
described the imagery in a sonnet:

> Her lute hangs shadowed in the apple-tree,
> While flashing fingers weave the sweet-strung spell
> Between its chords; and as the wild notes swell,
> The sea-bird for those branches leaves the sea.
> But to what sound her listening ear stoops she?
> What netherworld gulf-whispers does she hear,
> In answering echoes from what planisphere,
> Along the wind, along the estuary?
>
> She sinks into her spell: and when full soon
> Her lips move and she soars into her song,
> What creatures of the midmost main shall throng
> In furrowed surf-clouds to the summoning rune:
> Till he, the fated mariner, hears her cry,
> And up her rock, bare-breasted, comes to die?

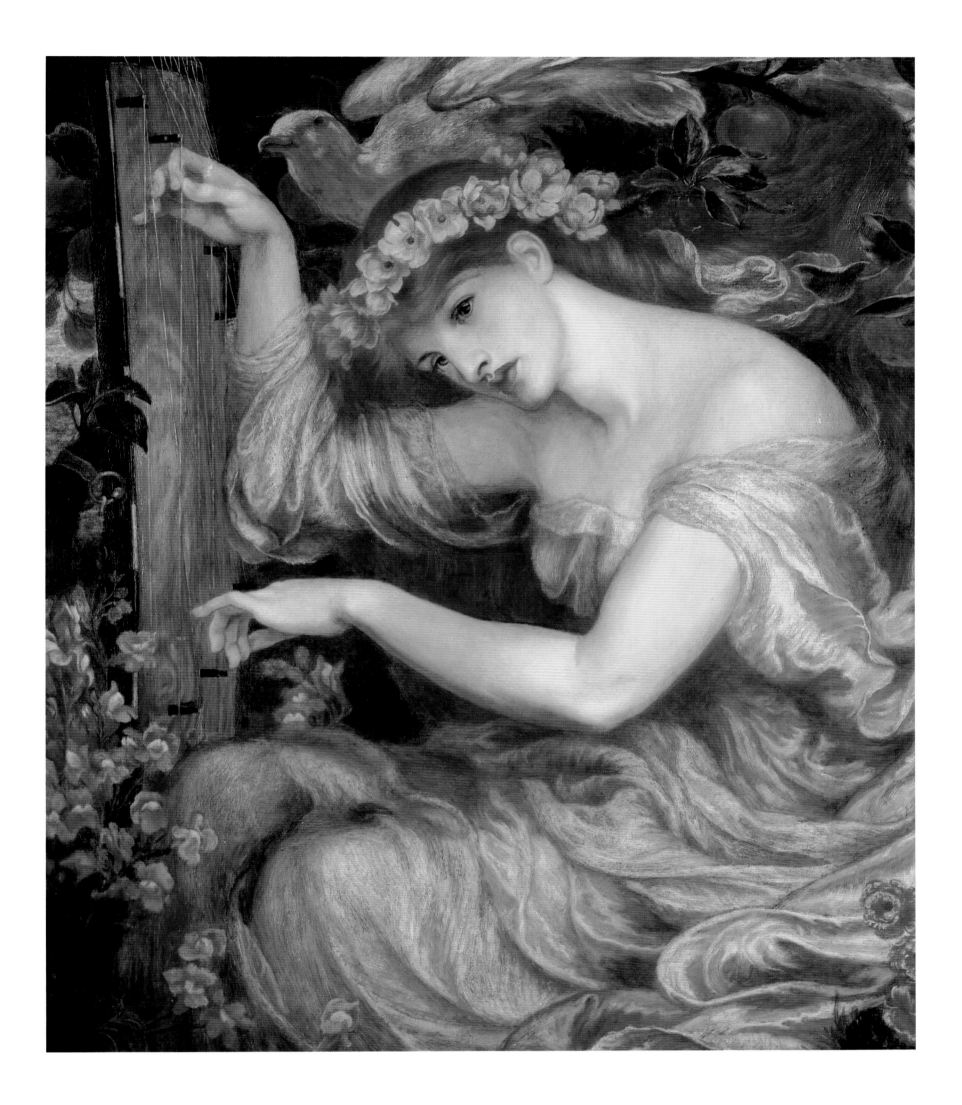

PLATE 38

A VISION OF FIAMMETTA
— 1878 —

Oil, 57¹/₂ x 35 in / 146 x 89 cm
Private collection

In 1861 Rossetti translated three sonnets by Boccaccio and encoun-
tered the story of Fiammetta. Fiammetta was the pet name of
Boccaccio's lover, Maria d'Aquino, who died prematurely.
Untypically, Rossetti painted only one version of this subject straight
on to canvas without studies. Here Fiammetta, modelled by Maria
Spartali, is overshadowed by the angel of death and surrounded by
apple blossoms. Rossetti had difficulty in finding good blossom in
London. As he wrote to Frederic Shields: 'I am very anxious about
the blossom…mine is not good enough to paint… What I want is a
full-coloured red and white blossom, of the tufted, rich kind; and
from such I began painting today, only it was not in a good state. I
would of course be glad to pay anything for a good blossom.'

On its completion Rossetti was very pleased with this painting,
which he described as a 'ripper', though it has remained relatively
unknown. It was *A Vision of Fiammetta* that inspired Samuel Bancroft
Jr to begin to collect Pre-Raphaelite art. This new patron tried
unsuccessfully to purchase the painting throughout the rest of his
life, but succeeded only in acquiring a watercolour study for the
flowers. Rossetti's sonnet on the same subject was inscribed on the
frame:

> Behold Fiammetta, shown in vision here.
> Gloom-girt 'mid Spring-flushed apple-growth she stands;
> And as she sways the branches with her hands,
> Along her arm the sundered bloom falls sheer,
> In separate petals shed, each like a tear;
> While from the quivering bough the bird expands
> His wings. And lo! thy spirit understands
> Life shaken and shower'd and flown, and Death drawn near.
>
> All stirs with change. Her garments that beat the air:
> The angel circling round her aureole
> Shimmers in flight against the tree's grey bole:
> A presage and a promise; as 'twere
> On Death's dark storm the rainbow of the Soul.

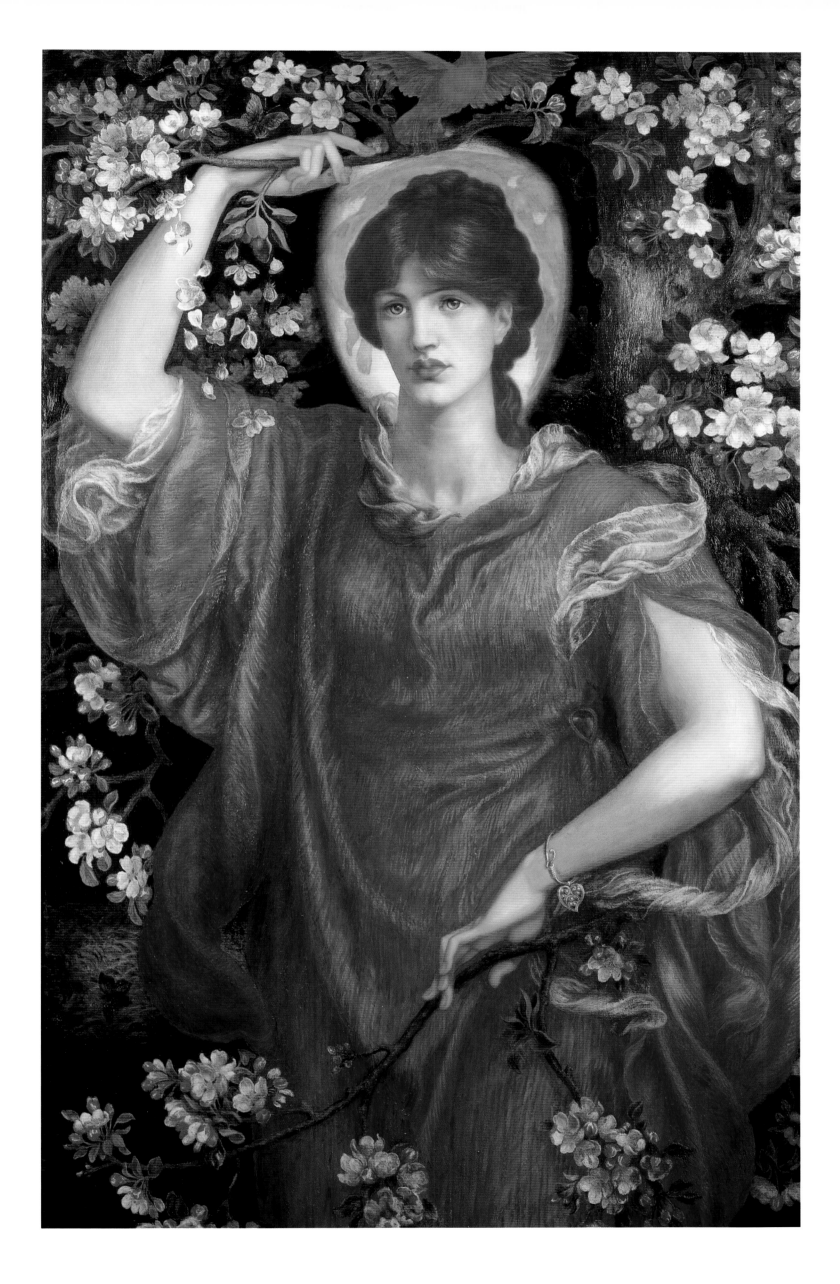

PLATE 39

LA DONNA DELLA FINESTRA
—————— 1879 ——————

Oil, 39³/₄ x 29¹/₄ in / 101 x 74.3 cm
Harvard University Art Museums, Fogg Art Museum,
Bequest of Grenville L. Winthrop

Described by Rossetti in a letter to Jane Morris in August 1879 as his best work to date, *La Donna della Finestra* (The Lady of Pity) was bought by F. S. Ellis for £420. The composition remained similar to that in 1870 studies upon which the work was based; again we see the Venetian half-length configuration. The window in the background was influenced by Dürer's engraving of *Saint Jerome* or a Friedrich Retzsch illustration to *Faust*. In May 1879 Rossetti wrote to Watts-Dunton:

'Today I have got on the background of the Lady of Window, and really the picture is quite transfigured and ought to sell. It looks as if I were not dead yet.'

The subject, yet another derived from Dante's *Vita Nuova*, refers to the 'Lady of Pity' who gazed down sympathetically on Dante from a window after the death of Beatrice. Allegorically the lady represented Philosophy, but to Rossetti she was Gemma Donati, the woman who eventually married Dante. The compassionate lady is undoubtedly also a reference to Jane, the model, in whom Rossetti sought solace after the death of Lizzie. By this time their relationship had become more affectionate than passionate, probably as a result of both Rossetti's chloral addiction and the needs of Jane's daughter Jenny (who had been diagnosed as epileptic). In July 1879 Rossetti wrote to her:

'I have put the fig-leaf foreground to your picture & it looks very well. I am in doubt whether to or not introduce a branch of laurel towards the upper part of the picture but if I do not do this it is now well-nigh finished.'

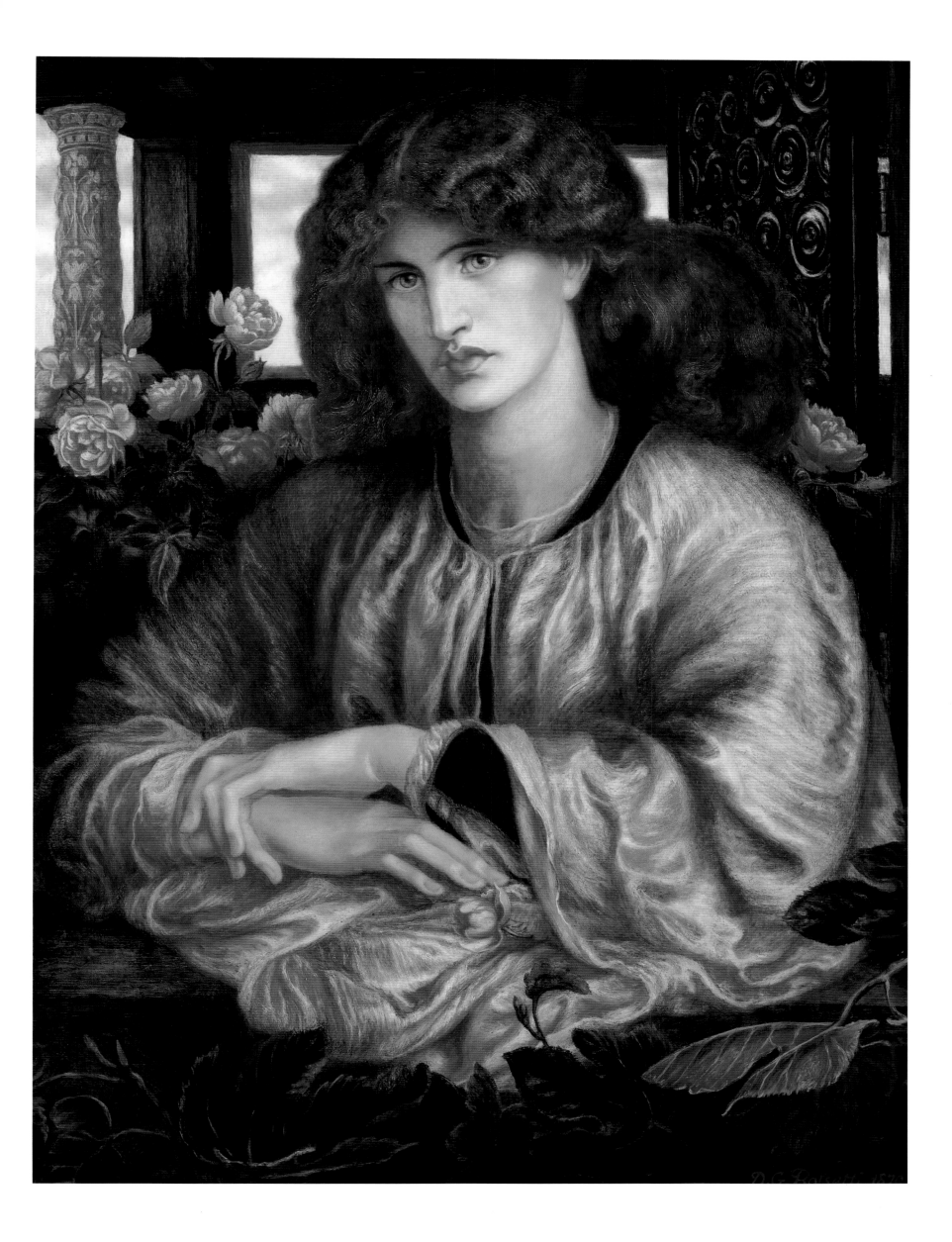

THE DAY DREAM
———— 1880 ————

Oil, 62½ x 36½ in / 157.5 x 92.7 cm
By Courtesy of the Board of Trustees of the Victoria and Albert Museum, London

In autumn 1879, on seeing a drawing in Rossetti's studio of Jane Morris sitting under a tree, Constantine Ionides commissioned this oil painting. In his correspondence with Jane at this time, the artist wrote:

'This will be a considerable commission, though I must be moderate in these bad times. Terms are not yet settled exactly. Do you know whether Constantine has bought or is buying any pictures of Ned Jones [Edward Burne-Jones]? Of course that worthy need not know of this matter of mine.'

Rossetti was indeed moderate with his price of £700 as it was clear that the wealthy Ionides would have paid considerably more. Rossetti believed that his modesty would be rewarded with further commissions.

In the earlier drawing the woman embodied Nature's creativity, symbolized by the return of Spring. Mrs Cowper-Temple had visited Rossetti's studio in the summer of 1879 and expressed delight in the study. Rossetti had written to Jane in July of that year, anticipating a commission and observing: 'So the old studies of you may go on being useful yet.'

Rossetti's plans for the painting underwent several changes. Originally it was to be entitled *Vanna* or *Monna Primavera*, referring to Dante's *Vita Nuova*. Snowdrops were initially chosen for the flowers, but were replaced by honeysuckle as the season progressed. The head was the second to be painted on to the canvas, having been altered at the request of Ionides's sister Agalaia, who felt the shadow on the face against the sky was too heavy. Typically, Rossetti subsequently described the imagery in a sonnet, which concludes with the lines:

> Within the branching shade of Reverie
> Dreams even may spring till autumn; yet none be
> Like woman's budding day-dream spirit-fann'd.
> Lo! tow'rd deep skies, not deeper than her look,
> She dreams; till now on her forgotten book
> Drops the forgotten blossom from her hand.

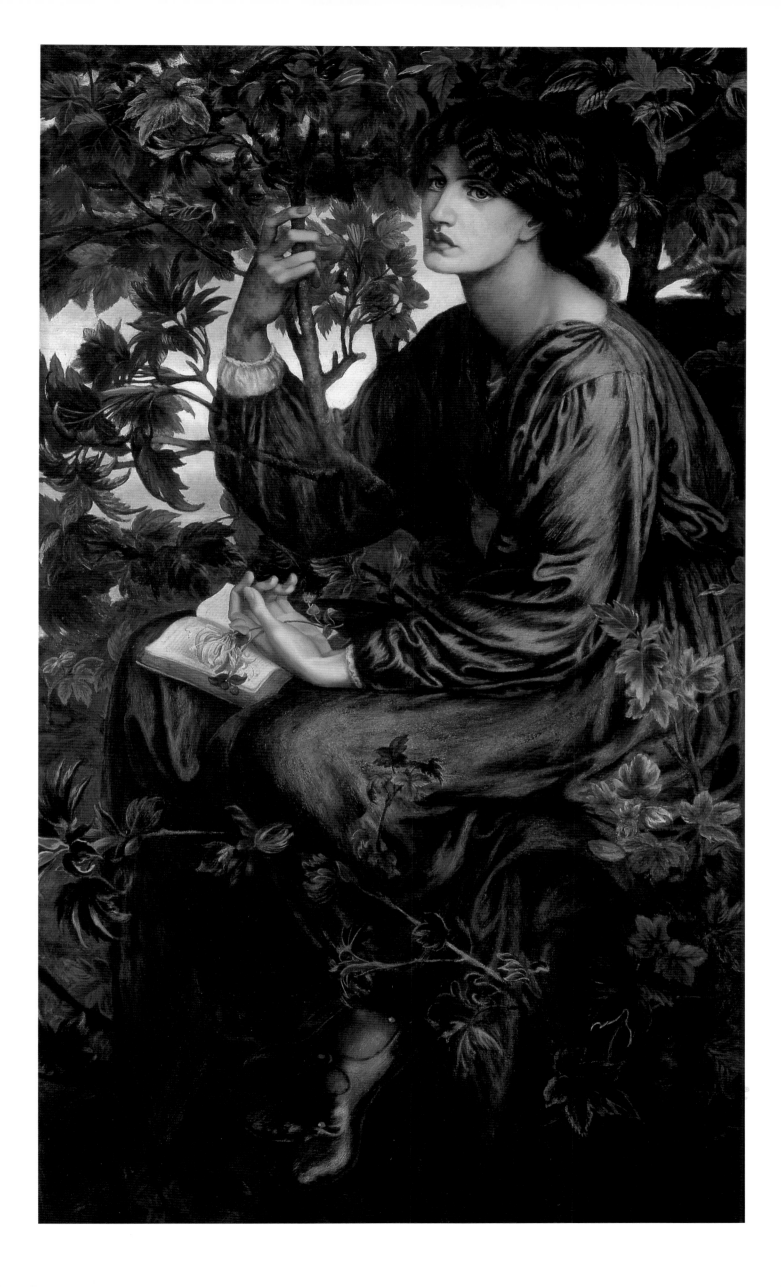

SELECT BIBLIOGRAPHY

John Bryson (ed), *Dante Gabriel Rossetti and Jane Morris: their Correspondence*,
Oxford: Clarendon Press, 1976

Gay Daly, *The Pre-Raphaelites in Love*,
London: Collins; New York: Ticknor and Fields, 1989

Oswald Doughty, *A Victorian Romantic: Dante Gabriel Rossetti*,
London: Oxford University Press, 1960

Oswald Doughty and John R. Wahl (eds), *The Letters of Dante Gabriel Rossetti*,
Oxford: Clarendon Press, 1965–67

Alicia Craig Faxon, *Dante Gabriel Rossetti*, Oxford: Phaidon Press, 1989

Francis L. Fennell, *Dante Gabriel Rossetti: An Annotated Bibliography*,
New York: Garland Publishing, 1982

William Gaunt, *The Pre-Raphaelite Tragedy*, London: Jonathan Cape, 1942

Marina Henderson, *D. G. Rossetti*, London: Academy Editions, 1973

Timothy Hilton, *The Pre-Raphaelites*, London: Thames and Hudson, 1970

John Nicoll, *Dante Gabriel Rossetti*, London: Studio Vista, 1975

Virginia Surtees, *The Paintings and Drawings of Dante Gabriel Rossetti*,
Oxford: Clarendon Press, 1971

Virginia Surtees, *Rossetti's Portraits of Elizabeth Siddal*,
Aldershot: Scolar Press, 1991

Tate Gallery, *The Pre-Raphaelites*,
London: The Tate Gallery and Penguin Books, 1984

Evelyn Waugh, *Rossetti: His Life and Works*, London: Duckworth, 1928

Stanley Weintraub, *Four Rossettis: A Victorian Biography*,
London: W. H. Allen; New York: Weybright, 1978

Christopher Wood, *The Pre-Raphaelites*,
London: Weidenfeld & Nicolson, 1981

The Rossetti Archive at the University of Virginia is available via the Internet
at URL http://jefferson.village.virginia.edu/rossetti/rossetti.html

PRINCIPAL PUBLIC COLLECTIONS CONTAINING WORKS BY ROSSETTI

CANADA

Ottawa
National Gallery of Canada

GERMANY

Neuss
Clemens-Sels-Museum

GREAT BRITAIN

Aberdeen
Aberdeen Art Gallery and Museum

Bedford
Cecil Higgins Art Gallery

Birmingham
Barber Institute of Fine Arts, University of
Birmingham
Birmingham City Art Gallery

Bournemouth
Russell-Cotes Art Gallery and Museum

Bradford
City Art Gallery and Museums

Cambridge
Fitzwilliam Museum

Cardiff
National Museum of Wales

Carlisle
Carlisle Museum and Art Gallery

Glasgow
Glasgow Art Gallery and Museum

Llandaff
Llandaff Cathedral

Liverpool
Walker Art Gallery

London
British Museum
Guildhall Art Gallery
National Portrait Gallery
Tate Gallery
Victoria & Albert Museum
William Morris Art Gallery, Walthamstow

Manchester
Manchester City Art Gallery
Whitworth Art Gallery, University of Manchester

Oxford
Ashmolean Museum

Port Sunlight
Lady Lever Art Gallery

ISRAEL

Tel Aviv
Museum of Tel Aviv

NEW ZEALAND

Auckland
Auckland City Art Gallery

SOUTH AFRICA

Johannesburg
Johannesburg Art Gallery

UNITED STATES OF AMERICA

Boston, Massachusetts
Isabella Stewart Gardner Museum
Museum of Fine Arts

Cambridge, Massachusetts
Fogg Art Museum, Harvard University

Chicago, Illinois
Art Institute of Chicago

Detroit, Michigan
Detroit Institute of Art

Lawrence, Kansas
Spencer Museum of Art, University of Kansas

New London, Connecticut
Lyman Allyn Museum

New York, New York
Brooklyn Museum
Metropolitan Museum of Art

Toledo, Ohio
Toledo Art Museum

Wichita, Kansas
Wichita Art Museum

Wilmington, Delaware
Delaware Art Museum

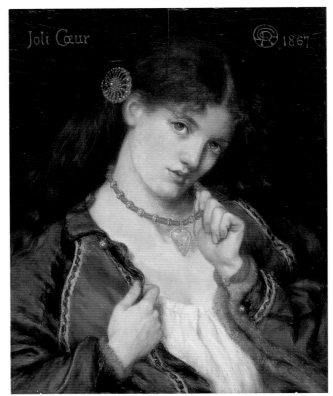

Joli Coeur, 1867

First published in Great Britain in 1995 by
PAVILION BOOKS LIMITED
26 Upper Ground, London SE1 9PD

Produced, edited and designed by Russell Ash and Bernard Higton
Text copyright © Russell Ash 1995

The moral right of the author has been asserted.

Designed by Bernard Higton
Editorial research by Vicki Rumball
Picture research by Mary-Jane Gibson

A CIP catalogue record for this book is available from the British Library.

This book is typeset in Monotype Perpetua

ISBN 1 85793 412 1

Printed and bound in Italy by Graphicom

2 4 6 8 10 9 7 5 3 1

This book may be ordered by post direct from the publisher.
Please contact the Marketing Department.
But try your bookshop first.

This edition published 1995 by BCA by arrangement with PAVILION BOOKS LTD

CN 4866